Drawing – The Purpose

Drawing – The Purpose

Drawing – The Purpose

Edited by Leo Duff and Phil Sawdon

intellect Bristol, UK / Chicago, USA

First Published in the UK in 2008 by
Intellect Books, The Mill, Parnall Road, Fishponds, Bristol, BS16 3JG, UK

First published in the USA in 2008 by
Intellect Books, The University of Chicago Press, 1427 E. 60th Street, Chicago,
IL 60637, USA

A catalogue record for this book is available from the British Library.

Cover Image: Defining Categories of Drawing Workshop,
MA Drawing as Process, Kingston University by Sue Clarke
Back Cover Image by Charlie Crook
Cover Design: Gabriel Solomons
Copy Editor: Heather Owen
Typesetting: Mac Style, Beverley, E. Yorkshire

ISBN 978-1-84150-201-4

Printed and bound by Gutenberg Press, Malta.

CONTENTS

Acknowledgements

Leo Duff and Phil Sawdon would like to acknowledge the following for their contributions along side the authors and those interviewed for their essays:

Kingston University London
Loughborough University
May Yao, Sam King and Intellect
Jane Twigg, who assisted with administration and collation

INTRODUCTION

Drawing – The Purpose is a collection of short essays from practitioners representing diverse professional practices. They have been invited by the editors Leo Duff and Phil Sawdon to contribute their thoughts on why they draw; to describe and reflect, within a maximum of three thousand words, on how through the example of their drawing they would describe drawing's purpose. The contributors' styles of writing and working are individual and idiosyncratic. Even though they are so disparate, comparison and contemplation on these essays will bring fresh insight to readers about the purpose of drawing.

This collection of essays follows on from *Drawing – The Process*[1] (2005), Editors Jo Davies and Leo Duff, which aimed to investigate the processes employed in drawing, i.e. how we draw.

Sometimes, one of the most challenging parts of any type of work is making the first 'statement'. Whether that is a written statement or a mark on paper (a drawing). One strategy to initiate some progress is to re-locate some of the task's keywords into 'everyday' language. This can create a potential for transient understanding, for play and some creative verbal and visual association. In order to facilitate this introduction, it may be worth a few moments to consider what is meant by introduction and more appropriately, bearing in mind this book's title, what is the 'purpose' of this introduction?

An introduction is normally considered as anything that introduces or prepares the way, specifically the preliminary section of a book, often containing material considered essential to an understanding and appreciation of the main text. The purpose, in the context of both this introduction and the essays invited and selected for inclusion in this book, is that they are all an introduction. An introduction to the way the individual practitioners see the purpose of drawing in making up their practice; an introduction to their way of working; an introduction to how they employ drawing with purpose in the work, regardless of whether it is seen (or not seen) in the final piece of visual art or object that is the end result. One might argue with regard to all the drawing practice represented in this book that it is 'just

something' one does, but it is 'the something' which leads the objectives for which the art work or object created exists. So let us introduce the topics of some of the purposes of drawing from an invited international group of diverse individuals.

The essays range from the viewpoint of the archaeologist Helen Wickstead's reflections on the purpose of drawing to those of a contemporary jeweller, Sarah O'Hana. Redrawing and layering her drawn information, Helen Wickstead recreates, investigates and reports evidence from the past. Sarah O'Hana reflects on how the giant machinery of previous engineering processes have influenced her experiments with drawn laser etching on metals, and her purpose in using drawing. Science is very much a part of both these practitioners' contemporary working methods, and drawing holds a major key to the way they develop, with purpose, the purpose in and of their work.

Vision in the designs of the artist and landscape architect Susan Kemenyffy is enhanced and developed through seeing natural form in terms of visual images, specifically for and through her drawing, and could not contrast more sharply with the diagrammatic use of line and flat tone to enhance total clarity in the information graphics designed by Nigel Holmes. Illustrator Andrew Selby makes work as imaginative recreation of place and purpose, involving cut shapes and collage, for use in the media; a strong contrast to how and why drawing is used to scheme and develop three dimensional objects by Russell Marshall, prior to measurements or materials being involved in product design for mass production. Thus project development and the purpose of drawing are explored in the essays, whether it is for the communication of logistics or schematics, instruction and explanation, narrative and social commentary, either as still or moving image, for long or short term viewing or use.

A common link throughout is how information and creativity is begun, developed and connected to communication within the individual practitioner's work without the addition or use of words. The clarification and purpose of the drawing must be evident and clear to those for whom it is intended, or the purpose for which it has been made, at the point when it is shared. Prior to that, the communication of the drawing, no matter how diagrammatic, is for personal reference and development. Those using drawing in design, those creating art works through drawing, be it two or three dimensional, on micro or macro scale, may not for some seem to sit comfortably alongside each other – for example the satire of a political cartoonist Dave Brown next to the drawing of a fine artist. This collection of invited essays aims to explore and discover the purpose that drawing holds across a range of disciplines and, through this, identify and highlight meanings and uses for drawing within our various practices by listening to the individual voices represented.

Several of the essays take, by choice, the form of a reflection on practice in a personally revealing way and, through this, contribute with a refreshing honesty to the unearthing and understanding of common grounds in drawing from different disciplines. Pat Gavin's experiences across several decades as one of the world's leading moving titles designers describe his dedication and dependency on

drawing to push forward, explore and discover the essence of his and the programme or film's intrinsic meaning. Andrew Selby and Dave Brown also work with mass production and popular exposure. The purpose of their drawing is clear and traceable through initial concept to final public output, yet their reflections empathize strongly with the working practices that Lin Chuan Chu and Hew Locke (interviewed by David Cottington) describe. Lin Chuan Chu and Hew Locke are successful fine artists whose work feed on personal experience and memory and answers to no one. The struggle within personal practice that drawing represents and upholds is thus laid bare by the contributors to this book.

The essays propose that through the application of drawing and its divergence across disciplines there are many points where subject specialist practitioners merge in their sense of purpose and reasons for utilizing drawing in their developmental work. Through presenting the voices of and articulating a dialogue about these individuals' purpose, our purpose is to enable further interdisciplinary understanding of drawing.

Leo Duff and Phil Sawdon

Note
1. Davies, J and L. Duff (2005) Drawing – The Process, Bristol: Intellect.

1

DRAWING WITH PURPOSE IN POLITICS

Dave Brown

Dave Brown is the political cartoonist for *The Independent*. He studied Fine Art at Leeds University, graduating in 1980. Before becoming a cartoonist he worked as a motorcycle courier and was the drummer in a punk band. In 1989 he won the *Sunday Times* Political Cartoon Competition and subsequently worked for a number of British newspapers and magazines before taking up a regular post on *The Independent* in 1996. In 2006 his cartoon *Venus Envy* was voted Political Cartoon of the Year, an award he had also received in 2003. In 2004 he was named Political Cartoonist of the Year by both the Political Cartoon Society and the Cartoon Art Trust. In 2007 his book *Rogues' Gallery*, a collection of political cartoons pastiching famous paintings, was published.

Dave Brown elaborates on his drawing as a political cartoonist and as a 'visual journalist'. He discusses the value and potency of a personal political point of view on the news of the day and how he is motivated by contemporary politics in his work. Working as a highly motivated political commentator, he sees his work operating as anti-establishment, 'to prick the pomposity of the so-called great and the good', though all within the parameters of the newspaper's philosophy. Trusting his personal sense of humour is part and parcel of his work, and keeping his satirical viewpoint to the fore is of equal importance in his completed drawings.

The purpose in his work is clear and expressed with agility in this essay, which also outlines his daily routine in working towards the ever-present deadline, taking into account how the news can change during the course of each twenty four hours. Five mornings each week with a blank piece of paper, after a brief discussion with the Comment Page editor, Dave Brown sketches from television, ruminates on quotations from various current scenarios and other sources to work towards meeting the demands of a daily broadsheet, and the position

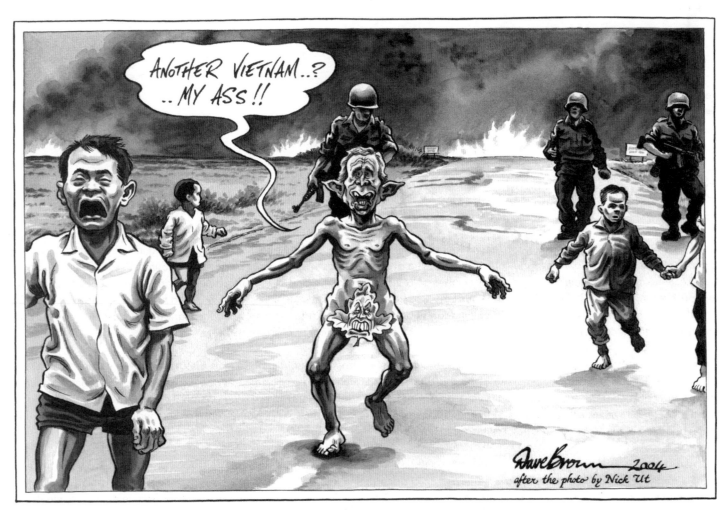

Another Vietnam.

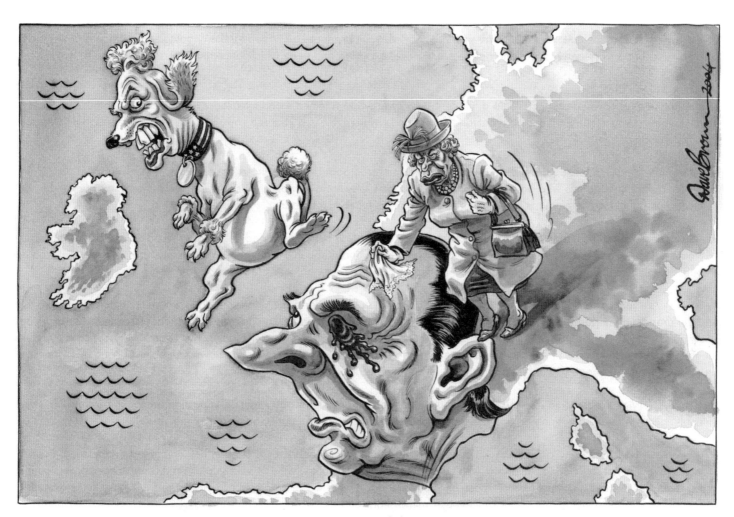

Entente Cordiale.

of his drawings next to the editorial leader. The sixth day, Saturday, he produces a cartoon for the ongoing series 'Rogues Gallery'. His bold drawings bring us clear messages and hold a prominence, exposure and perhaps influence that few artists ever achieve.

Every morning, six days a week, I sit down in my studio with a blank sheet of paper on the drawing board in front of me. By the end of the afternoon I must have transformed it into a finished piece of artwork, scanned it and e-mailed it to an office in London's docklands. The next morning you might see it at your breakfast table or on your train to work. That is if you still read a newspaper and if that paper is *The Independent*.

I am the paper's political cartoonist and on the newspaper's editorial pages I create those grotesque images of our own dear Prime Minister and the other leaders who govern us. Tomorrow of course they'll be wrapping your fish and chips (the grotesque images, not the leaders unfortunately), or perhaps – you being a conscientious *Independent* reader – in the recycling bin.

A rather ephemeral art then, looked at for a few seconds perhaps before being discarded. So what's the point? What's the purpose? Most national newspapers still recognize the need to employ a cartoonist (though worryingly some recently have decided they can do without); they understand that we help to enliven their acres of grey text. But what else are we good for?

My work still sits in the traditional position for the political cartoon, on the leader page. This is the page where the columns have no bye lines, but propound the paper's position on the issues of the day. Yet my cartoon neither illustrates those leader columns, nor expresses a view dictated to me by the paper. Rather it sits apart, it bears my signature; it is, if you will, 'all my own work'. My position is more like that of columnists also found on the editorial pages, expressing a personal point of view on the news. The political cartoonist is a visual journalist aiming to persuade you to his or her (almost invariably 'his') point with a drawn satire.

Once in an interview I was asked 'Do you draw with the idea, hope or intent that you might be impacting on public opinion?' This was cunningly followed by the question: 'Do you feel that you *have* had an impact on public opinion over the years?'

Now of course I'd love it if my coruscating wit could strip the scales from readers' eyes so that they embraced my personal political vision; however I'm not so deluded. A cartoon won't change the world. I doubt whether it's likely to effect a Damascene conversion in a single reader. But in a system where most of us can only tell our leaders what we think of them every five years or so, I'm in the wonderful position of being able to metaphorically poke them eye with a sharp pen every day.

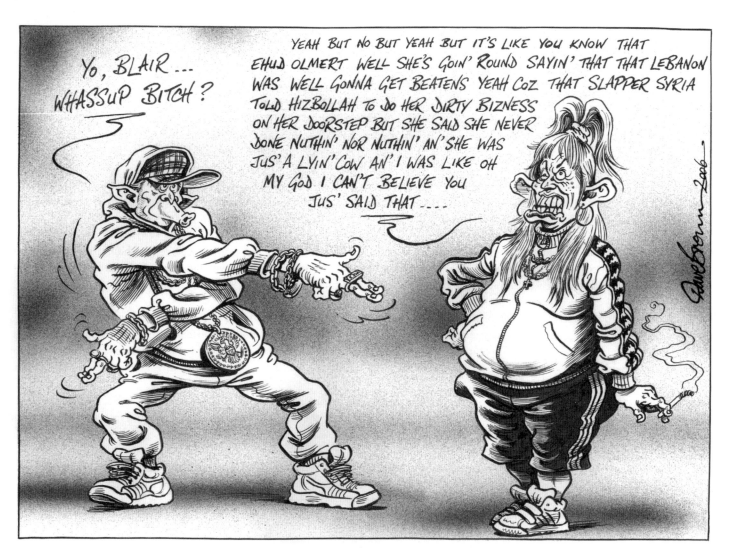

Blair.

Does this hurt them? Not as much as one would hope; mostly politicians ignore cartoons, some infuriatingly draw the sting by asking to buy the original (after all there is only one thing worse if you are a politician than being cartooned, and that's not being cartooned).

However, occasionally your ridicule does manage to rankle. I tend not to consort with the enemy but I was once introduced to a cabinet minister at a party who, on discovering who I was, complained about how I'd been drawing him recently. Needless to say, what had been a one-off gag became a regular feature of my caricatures of him, and this felt like some sort of badge of success, purpose paying off.

The cartoon is an art form with an amazingly broad language. It can combine images and words; static and two dimensional, yet it can convey movement, time and sound. Figurative, and to an extent realist, it can create an extraordinary range of fabulous characters and surreal settings that would cost Hollywood millions, all with little more than pen and ink.

Political cartoonists in particular draw upon a wide range of references from everyday life, popular culture and high art to subvert and make their point. A cartoon can often be (deceptively) simple and economical in its line. However, the space historically afforded to the political cartoon in British newspapers has led to a tradition of often fine draughtsmanship.

And the political cartoonist has to have something to say; like the gag cartoonist, we want to make you laugh, but with a purpose. There's no point to a political cartoonist without a strong political philosophy. There is always the need to challenge the reader to an extent, and not simply reflect their own views back at them (though of course editors rarely employ cartoonists who are completely antithetical to their papers' views).

Interestingly, the majority of the political cartoonists come from the left of the political spectrum and while there have been some successful right wing cartoonists, the profession by its nature seems anti-establishment; the desire is always to poke fun at those who hold power over us, to prick the pomposity of the so-called great and the good.

I have drawn since I was a child and was always fascinated with comic books, drawing my own characters and stories from a very early age. At secondary school I discovered that caricaturing the teacher was more amusing than staring out of the window, and had the added bonus of concentrating my view in the correct direction whilst my pen could appear to move diligently across my exercise book.

I studied Fine Art at university and then taught art for three years, all the time contributing cartoons to student and later Trade Union publications. I abandoned teaching to paint full time but had to support myself with a variety of other work from graphic and theatre

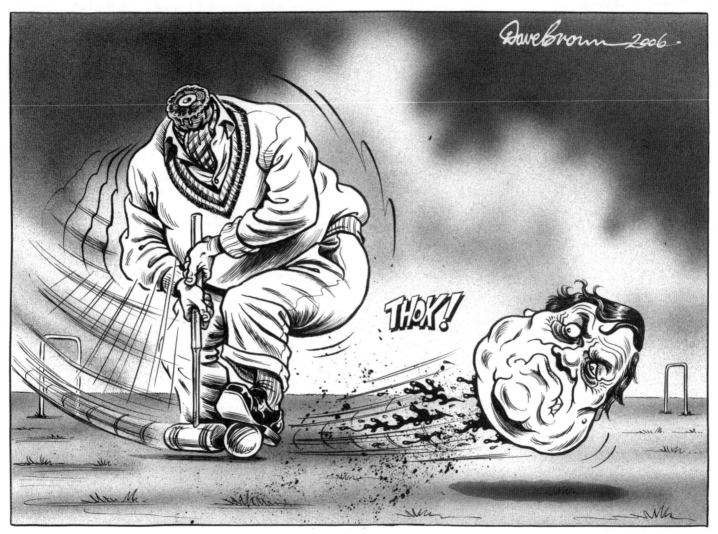

Croquet.

design to working as a motorcycle courier. It took some time to realize that what had been an amusing side line could be a full-time career, winning the *Sunday Times Political Cartoon Competition* in 1989 was the catalyst.

In the early years of my professional career I drew cartoons, strips and illustrations for a range of papers and magazines on a host of subjects, but it was always the editorial political cartoon that most interested me. Politics and Art have always been inextricably linked in my practice, whether as a painter, designer or cartoonist.

Now I work almost exclusively for *The Independent*, drawing five weekday cartoons where topicality is essential, and a feature called 'Rogues' Gallery' for the Saturday paper which is a satire on one of the themes of the week in the form of a parody of a famous painting.

I wake up as the Radio 4 *Today* programme comes on my alarm, and the first part of my day is spent with one ear glued to the radio while leafing through a pile of the morning papers, occasionally raising an eye to watch the TV rolling news stations. The idea of absorbing so much news is not simply to see what stories are playing big that day but to hear a wide a range of comment and interpretation, and possibly a telling quote from an interview, which might spark an idea. Also I have to be aware of what aspects of a story are being picked up by the media. I may personally want to focus on one particular aspect of a story, and I have to know that it will be familiar to the readers/viewers of my cartoon.

After 10.00am I call the paper and have a brief conversation with the Comment Page editor, to establish what story we think I should concentrate on. Some mornings there will be one that stands out and our conversation is over in seconds, on other days we may come up with a shortlist of equally valid topics, and it will be left to me to choose one which fires me up the most.

I then sit down with that blank sheet of paper develop an idea. This isn't really a 'light bulb over the head' moment so much as a set of mechanical work processes. There may be a quote I've already heard, or an image I've seen that will set the ball rolling. Modern politics is obviously very image-conscious, and many policy statements are made in set piece photo-op locations. Here the 24 hour news stations are very useful, and I may sit sketching in front of the telly to get the look of something happening that day, but I am also watching for anything untoward which may have escaped the spin doctor's choreographed news management.

Recently Blair was giving a speech at a community centre and stopped on his way into the building under a sign proclaiming 'The Folk Hall'; it was a cartoon begging to be drawn, with the letters O, L and H mysteriously going missing.

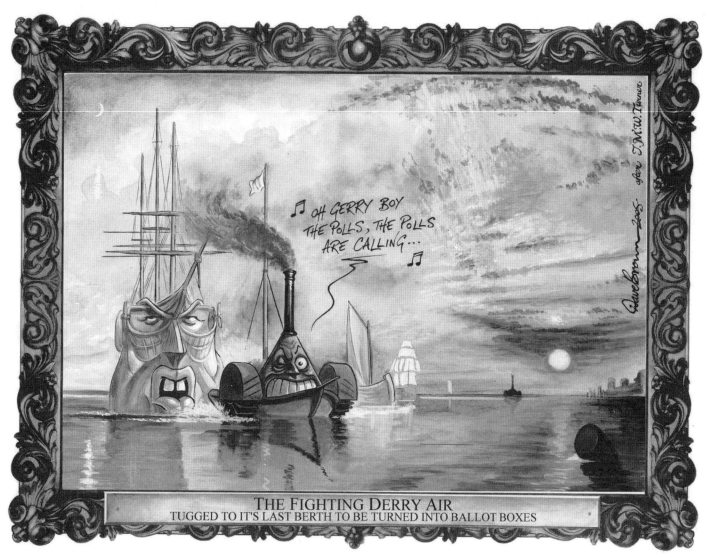

Derry Air.

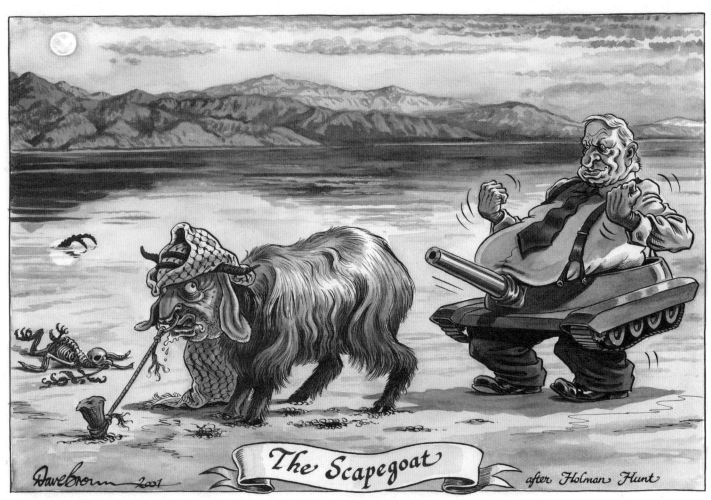

Scapegoat.

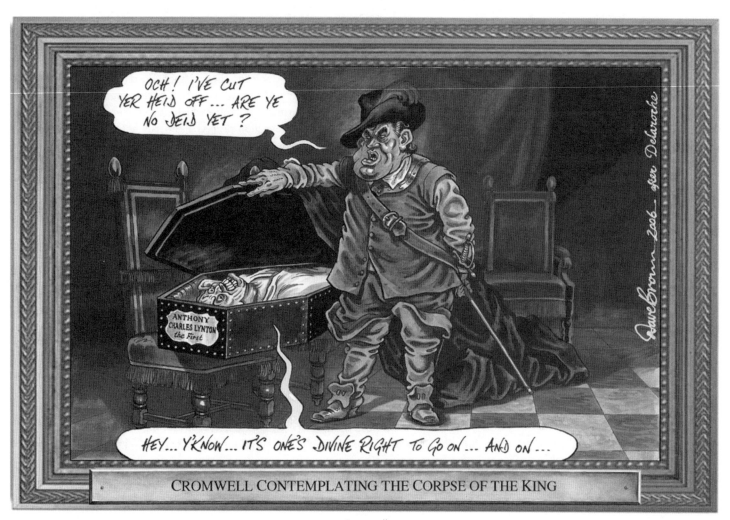

Cromwell.

When events don't offer such gifts and the idea isn't quite sparking, there are usually a few well-worn techniques you can rub together to get the fires burning: writing lists of aspects of a story, and utilizing word association to create new parallel lists; anything that creates unusual or surreal juxtapositions. Or visually, the actual stricture of working up a caricature, particularly of drawing someone for the first time, might suggest a likeness to some animal or object which provides the clue to depicting them. Usually in all this you'll have some sort of goal in mind; as I've said you've got to have a point you want to make, a purpose to the drawing. However sometimes, rather than working to find an image to express that point, you hit upon an apparently irrelevant image which nevertheless somehow grips in its absurdity. It somehow works as an image, but you're not sure what it means! Rather than dismiss it, the skill here is in spotting how it can be made relevant. Often these turn out to produce the best cartoons. I have the theory (completely lacking in any scientific rationale) that some images bypass logic to appeal to some more primitive part of the brain.

Once the idea has coalesced I rough it out quickly in pencil and fax it to the paper for approval. Sometimes I might want to check out if an idea 'works' or if someone else finds it funny; however, mostly it's best to trust your own sense of humour. Show the cartoon to five different people and you'll get five different responses. From the paper's point of view, the approval process is more to ensure that I haven't done anything which offends against 'taste and decency'. This basically means no bare bums or knob gags, although I do manage to slip one in occasionally.

As I've said, it's important to trust your own sense of humour; to draw what you find funny, and hope that it also strikes a chord with other people. However that doesn't mean you ignore your audience, completely. Your choice of topic will be partly guided by what the readers are aware of, and also your treatment of that topic. You can make some broad assumptions about readers of *The Independent* which mean that your cartoon might reference images from films, art or literature, without too much fear of being misunderstood.

Once the cartoon has been approved comes the easy bit, picking up the pen and producing the finished artwork. If the idea and developing the idea through the initial sketches and drawings has taken some time, the artwork may have to be simple. If inspiration has been quick, you may be able to lavish detail, and if the paper's pagination allows, even glorious Technicolor upon it.

However one ear remains glued to the radio throughout the afternoon in case of 'events, dear boy, events'. You may have to abandon the masterpiece, and with deadline looming, start all over again.

2

DRAWING ARCHAEOLOGY

Dr Helen Wickstead

Helen Wickstead has been involved with University College London, University of Bangor, University of Wales College Newport and the Workers Educational Association. She has taught undergraduate students in archaeological survey, Geographic Information Systems (GIS), archaeological field methods and Adult Education courses in Public Archaeology. She is Co-Director of the *Shovel Down Project*, Dartmoor, in Britain: an on-going research excavation funded by the British Academy, the Prehistoric Society and Dartmoor National Park Authority. This was the first situation in which she established a dialogue between drawing by artists and the work of archaeologists. She has also instigated a research project at the UNESCO World Heritage site of Stonehenge alongside the *Stonehenge Riverside Project*. Working in collaboration with Leo Duff, a group of artists, *Artists in Archaeology*,[1] was brought together to respond through drawing to the unique archaeological research taking place. This has, to date, been presented at the World Archaeological Congress in Dublin and at the Whitworth Art Gallery in Manchester and is an ongoing project.

This essay presents an insight into the most particular and exacting drawing in the collection making up Drawing – The Purpose. The purpose of this painstaking drawing and redrawing in archaeological recording is explained through personal experience and example. The act of seeing and drawing in an archaeological 'context' and how it generates interpretations, along with some thought-provoking ideas through the archaeologist's use of 'line' and 'edge', are also offered to the reader.

The drawings made by archaeologists are precise and meticulous with perfect referencing, both to a visible wood and cord grid and to its geographical positioning. Their drawings (on permatrace) need not only to be layered on top of each others, but also placed adjacent

COFFIN
1228

Skeleton. *Giles Dawkes, AOC Archaeology Group*

to drawings made by other archaeologists to form a factual jigsaw puzzle. Any slip up could spoil the interpretation of the dialogue created by these two dimensional renderings of three dimensional situations. The task is made more difficult by the fact that the subject matter is often drawn at such close quarters, making it virtually abstract in appearance, and more often than not the subject requires the archaeologist to crouch in awkward and uncomfortable positions.

The purpose of the drawing in recreating insight into situations, places and sociology of years gone by still holds a dominant position in the world of archaeology, despite the integration of digital technology in the archaeologist's practice, and this essay provides an intense example of art and science working together to enable questions to be asked and answers to be found.

'Fred' died several millennia ago. I carefully picked out his eye sockets this morning. We met in the bottom of a muddy ditch five kilometres from Prague, in the land once known as Bohemia. (In the truest sense, 'Fred' is a Bohemian). On our first meeting I mistook his skull for a stone, and cracked it with my shovel.

I raise my head up out of the ditch; 'what scale are we planning skellies?'

'One to ten.'

Wedging the planning frame against the ditch sides, and using a spirit level to keep it horizontal, I can get it so that the frame lies directly over most of 'Fred's' body. The string bisects his left eye socket at 51.7m east / 49.8m north precisely. I measure from the string to the nasal cavity, from the edge of the eye socket to where the skull curves away from sight. I mark each measurement with a small dot, using the gridlines under my permatrace to provide perfect scale. Putting my 4H pencil to the film I begin to draw.

Becoming a Field Archaeologist means learning to draw in a specialized way. Archaeologists speak of this process as 'getting your eye in'. 'I can still remember the site where I got my eye' says Jo, an archaeologist friend of mine, 'I was so proud of those drawings, and I took ages over them'. Despite working in a profession dominated by drawing, most diggers do not consider their work 'artistic', and when people speak of the 'creative arts' they rarely mention Archaeology. But I believe Archaeology creates in an important and intriguing way. The creativity of Archaeology works though an established set of practices; practices that combine digging and drawing so that they can hardly be separated; practices that allow us to imagine past worlds. What kind of 'eye' is it that we archaeologists 'get in'? How are we 'creative'? Take a closer look at how we draw.

Drawing the Line – 'Contexts'

Staring at the dirt I have scraped 'clean' I see a chaotic jumble of colours and a scatter of stones. Reuben slaps a hand on my shoulder.

'You've found it' he announces, 'It's the Norman Tower.'

I can just barely make out a patch with more green-grey mottles then everywhere else. It makes a squarish shape disappearing under the walls of the abbey. Perhaps there are more stones embedded in the shadow, but there are stones everywhere else as well. I look doubtfully at Reuben.

'I can't see an edge.' (I want to make sure that what I see is the same as what he sees).

'Yeah you can' he offers 'It's here'. He draws a line on the ground with his trowel, excluding some of the stones that I might have included.

'But wouldn't you say here?' I draw a rival line just outside his including the stones, which *might* be tipping down into something.

Noticing us having a 'conflab' Johnny takes a break from shovelling and ambles over. A short distance away he stops, considers the ground. He advances again and begins frantically scraping the soil a metre or so to my right. 'I'd take it back to here myself.'

Reuben scrutinizes, beginning to scrape, 'I'm not *convinced...*'

Trainees often find it difficult to 'see' edges. The act of drawing a definite line around something rests on reserves of professional confidence and interpretative skill. I have found myself literally inscribing a line on the earth for a perplexed trainee and instructing them; 'draw that'. What the archaeological apprentice finds difficult is the extent to which archaeological drawing differs from representational drawing. Archaeologists do not try to draw what they see with the normal eye. We do not draw the earth with all its mottles and flecks, its many different textures and patterns. Instead, we draw 'contexts'.

Seeing means, above all, the ability to see 'contexts'; Contexts are units of space and time – distinct events in the life of the site. In this instance, the 'context' might turn out to be the foundation trench for a Norman Tower. It is difficult make out because the stone of the tower was carted away long ago; leaving only what we call a 'robber trench'. What archaeologists prize about contexts is not only what they

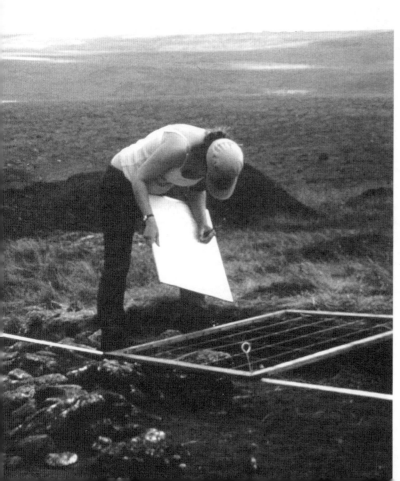

Becky Forrest drawing.

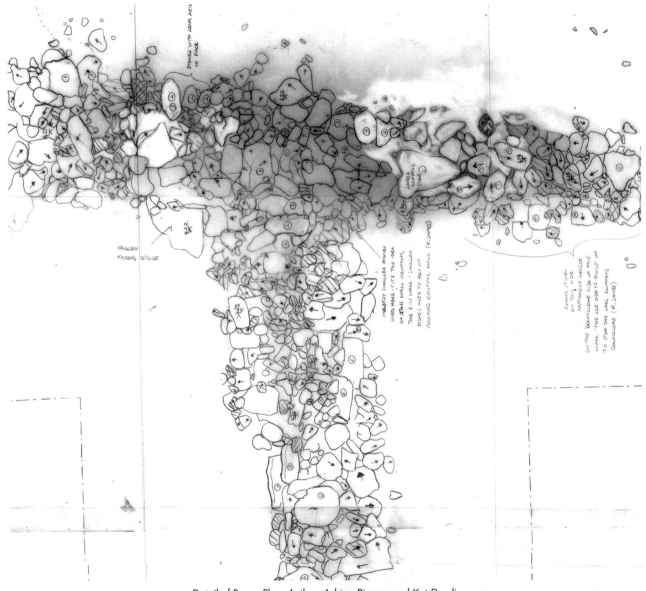

Detail of Pre-ex Plan. Author, Adrian Pigeon and Kat Dardis

are – ancient buildings, rubbish tips, graves – but also their relationships with all the other contexts we have found. When we know these relationships we can separate the older from the younger, building up a picture of what happened over time. Edges are important because they locate relationships. The edge delimits where one 'context' ends and another begins. For this reason archaeological drawings show great attention to outlines. Drawing a line forces us to 'make' an edge, even where the real edge is indistinct.

'Drawing something makes you have a different interpretation of it' says another friend. 'About 50 percent of drawing is interpretation.' Seeing and drawing a context generates interpretation. Discussions about what you can see in the ground involve proposing a story that accounts for what you think you see. Because every context relates to every other context on the site, what you think and draw affects what your co-workers will think and draw. An archaeologist's professional opinion must be reached through collaborative consultations, debates – and sometimes fierce disputes.

Digging and drawing work together. Drawing occurs before, during and after the digging of any single context. While digging and drawing continue, opinions may change: 'A pre-ex plan is a pre-ex plan' says my friend. 'Once you start excavating you're finding real edges and you haven't got the blurring of boundaries.' Discussions like the one I remember about the Norman Tower usually end as this one did; 'We won't know for sure until we dig it', or, as archaeologists sometimes express it – 'just hack it out'.

Discovery through Drawing – Stratigraphy

The word 'stratigraphy' comes from the Latin 'stratum' (layer) and the Greek 'graphos' (the drawn). Stratigraphy means the drawing of layers. A Field Archaeologist must master stratigraphy. To do our job we need to figure out the stratigraphic relationships between everything they see. We must peel off each context in the exact reverse order to that in which it appeared. Looking at any piece of ground we face a mass of contexts all jumbled up together. A Roman wall may sit directly next to the turf that grew yesterday, which may grow over an Elizabethan rubbish pit. We begin by identifying the most recent and working down towards the oldest. Drawing is part of how we do this. It disentangles contexts from their physical relationships in the earth. Transformed into a drawing, the mixed-up contexts in the earth can be ordered stratigraphically. Drawing co-ordinates digging, producing digging that is stratigraphic.

The purest method for drawing stratigraphically is 'single context planning'; this drawing / digging system breaks up all the drawings, so that each shows a single context. Drawings are made on semi-transparent drawing film (permatrace) that allows drawings to be layered one on top of the next. Layering drawings allows us to see how what we dig right now relates to what we dug away a few days ago. Looking back through drawings and layering them in different ways can produce startling new discoveries. For example you may find that a half-circle of postholes you dug last week matches up with the other half of the circle, only visible further down. Suddenly you realise that you have been digging an Iron Age roundhouse. Discoveries like these can change our understanding of the site completely.

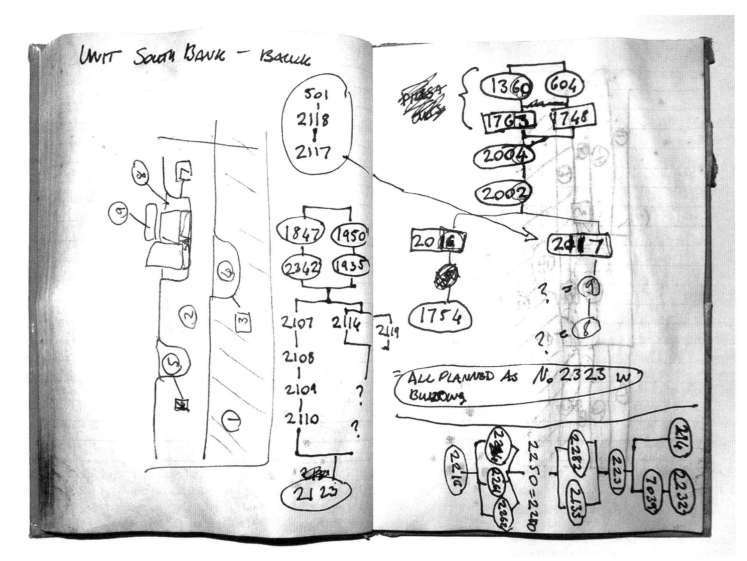

Author's notebook with matrices.

Hieroglyphs called matrices depict stratigraphy directly. They order contexts in a highly abstract way, emphasizing a concept of time over everything else. Matrices work out stratigraphic conundrums. Wherever we congregate and converse, matrices appear. We inscribe them in the margins of other drawings, and on written proforma, we scrawl them on scrap paper, we graffiti them on desks and walls, we incise them into the surface of the soil. They emerge almost unbidden as a by-product of how stratigraphy works our minds.

Collective Drawing – Conventions

Every archaeological drawing expresses the same visual language, the same standard conventions. A hard line means one thing, a dashed line means another, and a dot-dashed line means another thing again. We also have a special way of showing 'negative' contexts – events that resulted in holes and hollows. Drawings made in the field comprise 'plans', 'sections' and 'elevations'. Plans show the context from above like a map, sections illustrate cuts made vertically through deposits, and elevations depict the vertical faces of buildings. Archaeologists value accuracy and precision in drawing. Someone who has 'got their eye in' has internalized an ability to draw to scale. While the new recruit stops all the time to take measurements, the drawing of someone with 'their eye in' flows. They pause and measure only rarely. They know all the established conventions. Ideally, they become an instrument, calibrating their eye to scale.

Archaeologists collaborate when they draw. Trainees prefer to draw with one person taking measurements and the other joining the dots ('Ah', sighs the old lag, 'they haven't got their eye in yet'). Complicated contexts may be drawn by a team working in different areas then retracing their drawings into one. One person may begin a drawing and someone else may complete it. Archaeologists are proud of their drawing skills and are prompted to initial their drawings. Within the community of excavators a technically accomplished drawing is admired. However, the people who draw on site are seldom recognized outside the trench. Individual drawings are only fragments; part of a much larger collective drawing.

Layering of two elevation drawings showing inside and outside of a building.
Les Kapon, AOC Archaeology Group

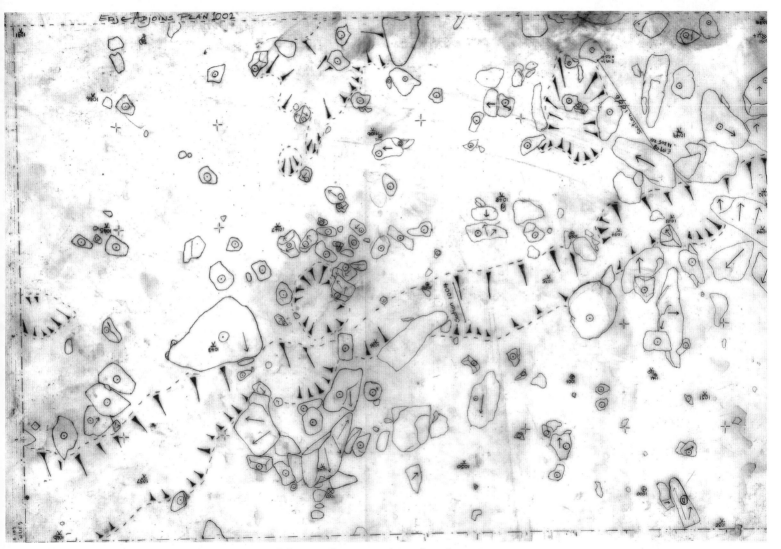

Collaborative drawing. *Declan Kelly and Brian Feeney*

Drawings about Drawings – Narrative

Every drawing made on an excavation comprises a tiny component part of one huge drawing. This vastly complex drawing will only be complete when the digging finishes. Visiting an excavation you will see archaeologists working from day-to-day; trying to recognize contexts; drawing; discovering things; drawing again. What you might not see is the enormous amount of work taking place behind-the-scenes which also continues long after the dig has been sealed up. This is the work of ordering and indexing drawings, checking their numbers, checking their horizontal and vertical coordinates, locating them in relation to everything else. Every single context plan is redrawn using the computer mouse. Inside the computer all these tiny component drawings accumulate. Hundreds of little drawings integrate, making a single vast drawing; an enormously complicated, three-dimensional map.

Phil directs large excavation projects. He oversees the whole process of making archaeological knowledge from digging to publication of reports and monographs. After the site closes, Phil is left with sheaves and sheaves of permatrace, and a huge digital drawing. The quantity of information amassed in these drawings – their complexity – overwhelm the capacity of a single mind. To understand the drawings, Phil and his post-ex (post-excavation) team need to draw even more.

Right up until the final deadline Phil and his colleagues will draw and redraw as their thinking changes. 'One is constantly experimenting with alignments, groupings, boundaries between land use areas, finds-clusters or spreads, whatever, in a search for meaningful pattern within each phase'. 'I rely on drawings' he states 'as the fundamental vehicle for developing a site narrative'. He has to develop a story of the site. But most sites Phil excavates are very complicated. To tell a coherent narrative, he needs to generalize and select. He needs to excavate the drawings. Where are the beginnings, the turning points, the showdowns, the births and deaths? Where is the drama in the story of the site? To find out, Phil and his team make drawings that help them to investigate the drawings they already have.

Post-excavation, drawings depict and comment on other drawings. An overall matrix that integrates everything on the site must now be produced from all the fragmentary matrices that have accumulated. Where a site is large and complex, matrices will be giant drawings, covering entire walls. They produce chronological order but do little to reduce the complexity Phil faces. Drawings that generalize and explain are also needed. Two such genres of drawing are 'land use diagrams' and 'phase plans'.

'Land use diagrams' group contexts into 'land uses' – functional blocks of time/space. On a single page they summarize how each group occupies space and time. Time is arranged on one axis and space on another. This 'forces the analyst to account for the use of the entire site throughout history' as Phil puts it. It is a way of finding the continuities and discontinuities of an emerging narrative; locating the dramatic content of the story. Few of these diagrammatic drawings are ever seen in the published record. They are behind-the-scenes drawings; processes of working out rather then 'finished' productions. 'You dispense with the land use diagram quite early in the analysis'

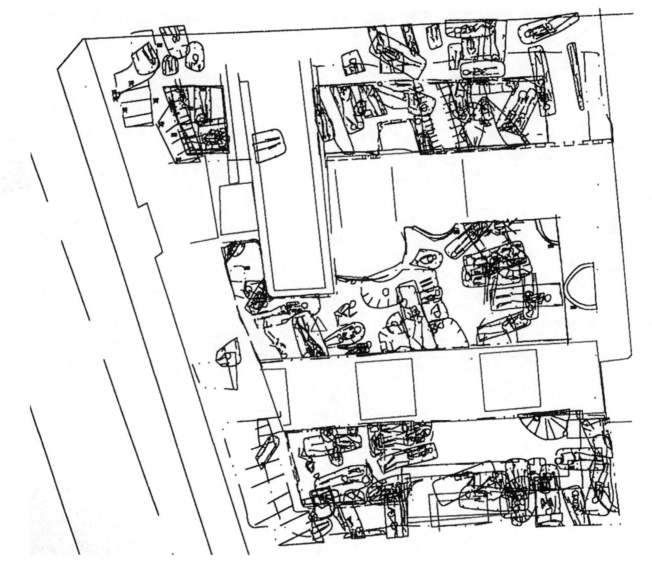

Fragment from digital drawing of All Hallows Tower, showing layers and layers of contexts, many of them graves. *AOC Archaeology Group*

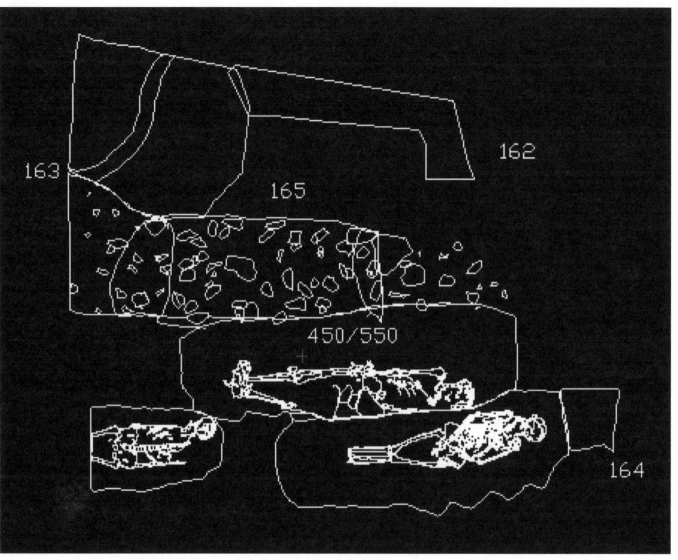

Phase plan; component of Multi-phase plan. *Reuben Thorpe*

reports Phil. 'At some point you concede that you're not trying to account for the use of land throughout the whole of time and space; you're trying to write a narrative of what went on'.

The 'multi-phase plan' slices through the mass of drawings that represent the site in plan. Groups of contexts are summarized into (for example) the Late Saxon phase, the Norman phase, the thirteenth to the fifteenth centuries, etc. For the first time in the drawing process, colour becomes an important tool. Phases are colour coded and superimposed, producing layered chronological images.

Drawings remain 'in a dynamic state' until Phil completes his report. But publication is never the final word in archaeology. Transformed into drawings, the site does not disappear. Drawings are curated in an archive, preserved for those who might revisit them in future. Archaeological ideas – our stories and what we find important in them – are always changing. We are always going back to drawings, to find what others have missed, in the hope of new discoveries.

Creativity in the Bones

'Fred' and I would never have met if some ancient Bohemians had not decided to leave his body in a ditch. It was a peaceful afternoon and drawing him I felt I got to know his old bones. As I drew him I wondered about what he had seen in his lifetime. How did he end up in this ditch? Encounters that bring us face-to-face with the dead have a habit of interrupting our everyday world; sounding a gap between us and them. Producing these encounters, Archaeology creates both the gap and a means of bridging it. It creates knowledge that enriches the encounter, refining our questioning, supplying grist to the imagination. By drawing and drawing and drawing again, we let something material from another time act upon us, drawing us into the past.

Acknowledgements: Jo Lyon, Reuben Thorpe, Johnny Taylor, and 'Fred' participated in the memories which were mined for this writing – thank you all. Interviews with Phil Emery helped me describe the post-excavation process for deeply stratified urban sites. I found Tom Yarrow's analyses of how archaeologists create knowledge very useful for thinking about how we use drawing. AOC Archaeology Group generously allowed me to research their drawings – many thanks to Fitz for helping me access them.

AOC Archaeology Group is Archaeological Operations and Conservation, for more information see; http://www.aocarchaeology.com/home.htm

Note
1. www.artistsinarchaeology.org

3

DRAWING WITH SCIENCE

Sarah O'Hana

Sarah O'Hana graduated in Silversmithing and Jewellery from Loughborough College of Art in 1982. She is currently researching Laser Processing for Contemporary Jewellery at the University of Manchester. She works as a maker of jewellery, a curator, and she is co-director for *Ars Ornata* in Manchester.

This essay offers a contribution to dialogue between art and science by outlining how drawing and the manufacturing of contemporary jewellery can operate together to create new ways of making, supported by scientific knowledge. Systems from both cultures are interlocked in the interest of re(de)fining their language and finding a common ground in both drawing and jewellery making.

Leaving the comfort zone of her own practice as a jewellery designer to 'see what's out there', Sarah O'Hana has taken a step into an unknown territory of engineering and science; a challenging but fascinating move that provides new information for both disciplines.

The drawing of a dramatic landscape provided inspiration and underlines the purpose of drawing for the development of a technique of drawing with a laser to create a specific rough appearance and finish to metal jewellery. Sara O'Hana describes how her experiences with drawing and the understanding of mark-making led her to develop use of the laser as one would a pencil or pen, and how her understanding and interpretation of scale as understood in drawing led her to use a scientific factory setting as inspiration for some of her subject matter.

'It is up to the engineers and scientists who create these technologies to explain what they have done in a language that can be understood by non experts'. (Broers 2005)[1]

There is a natural curiosity within art and design to investigate emerging technology for new methods of creation. Increasingly, though, hands are being replaced by keyboards, resulting in the sidelining of essential tactile contact with materials. According to Lord Broers, the future of the human race depends on technology. He also underlines the importance of collaboration, but the gap between science and art continues to grow as these subjects are so divided that a mutual ignorance of each other's practice is traditionally accepted and established, right from the beginning. If you wanted to study art with engineering or with science you would, unfortunately, find it quite difficult. Yet the two are not so dissimilar, and when they speak to each other the results can be extraordinarily fruitful. A clear example is the recently published book *Pollen'*[2] by artist Rob Kessler and Madeline Harley, head of the palynology unit at Kew Gardens.

Engineering + Drawing

I first looked at what was 'out there' as a student, when my father, an engineer, took me on site to a power station he was managing in Spain. He revealed what I saw as an awesome library of shape, form and function. I was training as a jewellery designer at the time, so the sheer scale of the plant and its complexity far exceeded my boundaries as a designer of small and intimate objects. Here was another culture, I realized, that concerned itself with designing, problem solving and constructing. The titanic elegance of the oversized machinery and the practical use of bold colour around the site were to form and leave a powerful impression and inspiration in my mind.

An upbringing in Spain ensured that I return to Mallorca frequently, where I now explore and exploit my obsession with drawing. The light is unequalled and the landscape dramatic. I have drawn the same rugged scene many times, trying to see shape and changing colour, distance, transparency and heat; observing the formality of houses within the landscape of cypress and olive trees, delighting at the violent contrast between light and shadow in such a hot climate. I draw to understand all these elements, to feed the imagination and to find design inspiration. I draw because I need to, much in the way that a writer might need to spend time reading. As a maker of objects this has some logic, and the collaboration between drawing and making within my own practice is obvious, although not always straightforward and linear. The simultaneous advance of the multi-stranded animal that is art practice is in constant evolution. It is a question of harnessing the resulting energy into considered shape and form. Jewellery is unique in its demand to be 'finished' as a predominantly wearable art form; skill and ability in the making are important, even when the final aesthetic is designed to be 'rough' or 'unfinished'.

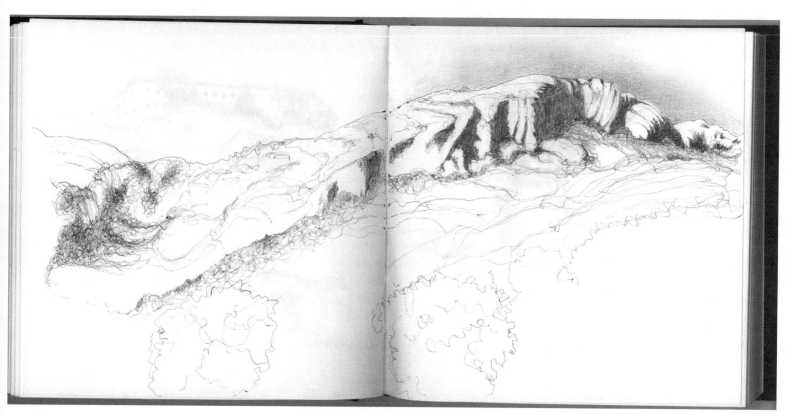

Pollença.

Jewellery

I am cautious with the word 'jewellery', however. It conjures up instant images of diamond solitaires and gold lockets that are far removed from the kind of objects I refer to here. A change in jewellery design has been taking place over the last four decades which is nothing short of a revolution: the forging of a new art form which has thankfully challenged, once and for all, the concept of what is 'precious' and what is considered to be 'acceptable' personal (and extra-personal) adornment. Precious metals or stones are no longer the main concern; appreciation of alternative materials, freedom of aesthetic, and a concept more in line with fine art practice has become the order of the day. Boundaries blur, even into the realms of film and performance. With this in mind, I consider the new jeweller more of an artist than a designer; best described as an artist designer, which is in huge contrast to the days when, amidst some debate, we were still confined to the lower echelons of art practice. Contemporary jewellers are now a healthy combination of the two.

The battle is not yet over though, as the word 'jewellery' continues to broadcast the wrong message and contemporary practitioners struggle to find an alternative expression which best describes their practice. But this young art form has all the precocious optimism and hope of a teenager, and its temperament, so beautifully illustrated in the exhibition *Maker, Wearer, Viewer*[3] speaks of conceptual, personal-theoretical and particularly narrative elements that aim to engage the artefact in a unique relationship with its owner. The traditional stone-encrusted necklace is no longer alone in being the messenger of wealth and status. A piece of contemporary jewellery is equally potent in its ability to relate confidence, comment or celebration. In some cases the materials might well be 'traditional', but the deconstruction of historically applied and received design has liberated materials, both traditional and new, into a cosmos of new possibility. This also presents contemporary jewellery as a perfect vehicle for conversation, discussed as an art piece rather than viewed as a conspicuous object of financial worth.

Laser

Match this with another revolution, also in the last four decades: the discovery and development of laser technology. The ACJ[4] conference of 2000, 'A Sense of Wonder', awoke with a start this technologically dormant sector of the arts by announcing the arrival of hitherto inconceivable manufacturing and visualizing systems. Tools used by jewellers have not changed much since the eighteenth century, so the arrival of new technologies was an unexpected and welcome surprise. It has taken industry some time to realize that this small sector we call the creative industries is quite capable of putting new technologies to different use; frequently with more creativity and lateral thought than it was originally intended for, and in some cases resulting in mass manufacturing and enormous profits. As leader of a newly established course in applied arts, I have been engaged with the introduction of new technologies and in particular with laser, anticipating the inevitable impact it would have on jewellery construction techniques and appearance.

Probably the first project to address the need for artists to understand more about emerging technologies was *In the Making*,[5] a short course for professional artists offering hands-on instruction and development in new technologies. Most of the interest was created around laser processing and, as different materials were put to the test under the beam, it became clear that the 'let's try it and see what happens' approach could do with more consistency and analytical understanding. Very importantly, this course recognized the importance of dovetailing the technology with the artists' handling of materials, such as through drawing.

The following projects took into account the need to engage in conversation that addresses the yawning gap that exists between arts and sciences.

Titanium is one of those metals that sounds 'precious', like platinum, but is not in fact part of the precious metal group. It is white, similar in colour to aluminium, light, strong and corrosion-resistant. Few jewellery designers will put up with its unyielding qualities but those that will, do so partly because of its colouring potential. This is not an application of pigments but an oxide layer caused by applying heat or by electrically anodizing. The colour that can be observed on anodized titanium is an optical phenomenon known as interference. In this phenomenon, both the metal surface and its microscopic film of oxide (caused by applying heat or anodizing) reflect light. But as white light rays enter, the oxide film it is broken up and refracted from the metal surface back through the oxide layer into the eye as multiple reflections. It is the different thicknesses of oxide that cause the film to appear as different colours.

Laser is an acronym and stands for Light Amplification by the Stimulated Emission of Radiation. The lasers used in this project are CO_2 (where the active medium is carbon dioxide) and Nd:YAG (where the active medium is Yttrium Aluminium Garnet). The main characteristics of laser radiation (laser light beam) are:

- Monochromacity (radiation that has only one wavelength).
- Coherence (light waves travelling in phase).
- Collimation (very narrow, low diffracted beam).

The use of a laser beam for creating oxides on titanium offers a very precise control of the intentionally affected areas. As the beam traverses the workpiece, heat from the laser creates oxide layers which appear as colour in the same way that anodizing does.

The following jewellery series exploits this process, using the laser beam as far as possible as a 'drawing' tool to convey a visual message on the titanium surface that engages both cultures in a search for contact.

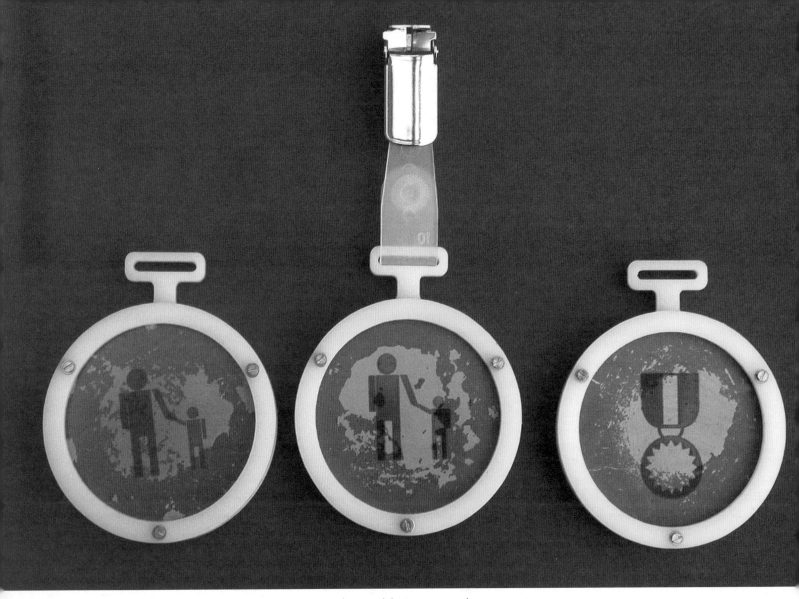

Three medals. Titanium, acrylic.

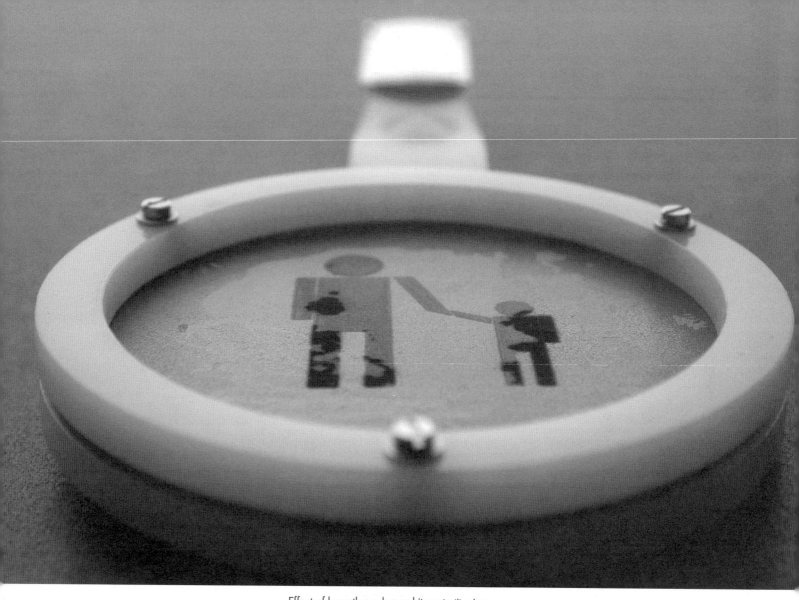

Effect of laser through graphite onto titanium.

Laser marked titanium.

'ID' medals

This group of twelve medals, some of which are illustrated on the previous pages, draws on instantly recognizable imported images. Symbols rank amongst our oldest and most basic inventions but the way they effectively convey a precise, instant message means they are very much in demand in the digital age, matched with equally precise technology.

The titanium was marked (oxidized) with a CO_2 laser and housed in a frame of acrylic cut by the same beam using different parameters; in effect drawn onto the titanium. Graphite was initially applied to improve the conductivity of the laser onto the titanium and to reduce reflection of the laser beam back into the system, but produced an unexpected visual effect then used deliberately in subsequent pieces. Observing the image on p. 35, areas that have been sprayed with graphite appear corroded where the laser beam has traversed them, causing the laser to behave like a pen through carbon paper.

The medals are the first in a series of work relating to the identity of the wearer and are the beginning of a conversation between imagination and technology, via drawing, expressed on jewellery. The development of subsequent work hinges on the interaction of both artist and scientist, as both are now engaged in the making.

'ID' cards

The 'identity cards' reflect the call of technology which frequently dictates a geometric style of design. My intention here is to offer a more painterly, freehand approach to the pieces, as if they were pages from a sketchbook. The cards were cut to credit card proportions and are cut with Nd: YAG pulsed laser to purposefully fit the plastic holder typically used for security passes. Continuing the theme of personal identity and working within an engineering environment brings into question different aesthetic values with which artists and scientists identify, thus the four cards illustrated explore details of magnified drawings taken from a sketchbooks on one side (p. 38 and 39) and, on the other, numerical data taken from a strength test in a previous project (p. 39). The identity cards are designed to allow the bearer right of entry to both art and science communities, in an attempt to bring together cultures which have strayed apart. For this reason the cards are two-sided and reversible; wearable by either culture as a 'pass' into the other.

'ID' card 1. Laser marked titanium.

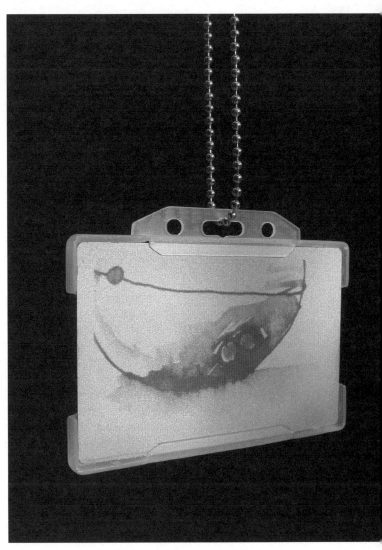

'ID' card 2. Laser marked titanium.

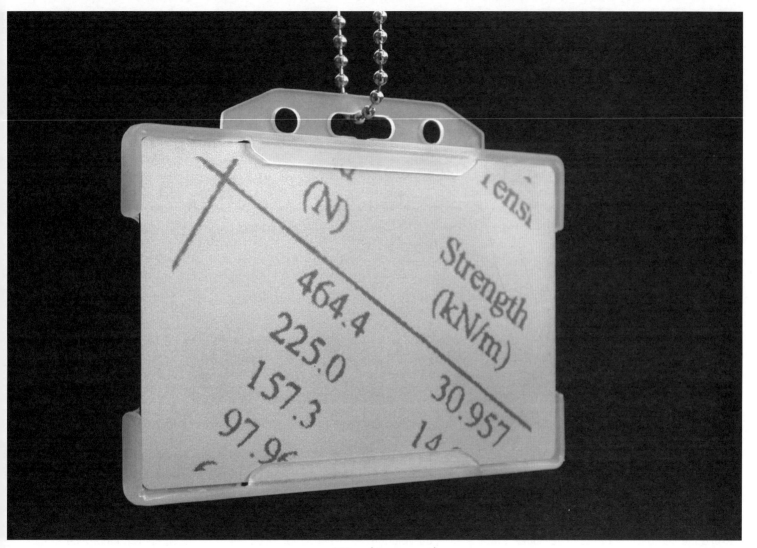

'ID' card 1, reverse side.

'Heirlooms' ring

This ring responds to the ACJ's exhibition *Heirlooms*.[6] The theme focuses on issues of value and responsibility, with particular attention paid to ecology, ethics and sustainability. Wondering what kind of artefacts archaeologists will find in the future, and what they will reveal about us, the ring attempts to give some indication of the concerns raised in this research involving the marking of titanium by laser: the cultures that are involved and the legacy it will leave.

With this ring the recipient is offered an insight into current technological advances, and the recipe to make their own copy. Using the conventional method of knowledge transfer, together with the traditional representation of a diamond solitaire, the ring is formatted in much the same way as a book. The titanium outer covers of the ring are 'drawn' on by laser to produce a purely decorative pattern that protect the inside pages. These miniature pages of tracing paper unfold to reveal the dimensions, tools, method and ingredients needed to make the design, all of which are laser marked, drawn by laser.

The ring is a vehicle for communication: for the imparting of replicable knowledge taken from the scientific and engineering cultures as well as from art and design; made of an alloy that takes time and patience to mix and is represented here by the difficult marriage of titanium and paper.

Hands – Software

Jewellery has made contact with science and engineering; the objects in evidence transmitting their ideas, available for display or discussion. Emerging, however, is a worrying thought: the very technology that I sought to exploit for the benefit of art and design is steering the hand away from the notebook and drawing more precisely, away from the pencil. Software drives lasers, not hands. For the technology to fit comfortably as another tool in the workshop there needs to be an important investment of time.

This is turn has led me to two conclusions: first, that I now feel the need to put pen to paper all the more urgently out of the resulting frustration, even if just for the purpose of hand-writing – a significant mark-making exercise in its own right and another method of exploration into my practice. Drawing by keyboard does not satisfy the same physical need. I have turned to drawing with renewed appetite, realizing its essential role within my practice, and elevated it to its deserved status, celebrating the sketchbook/journal. Manual skills are becoming like an endangered species and the question is being increasingly raised, particularly with respect to early learners in our schools: will these skills fade in the digital age and does it matter if they do?

Despite the introduction of haptic technology which relies on virtual three dimensional touch, there is still an implicit ignorance of the material unless the hand is involved directly. This is because hands feel pressure, can grasp and touch on more than one plane at once.

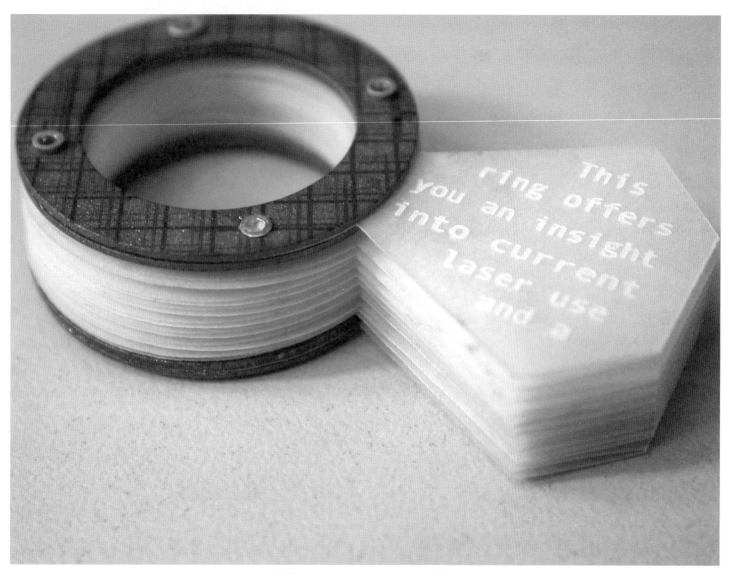

Heirlooms ring. Titanium, paper and silver.

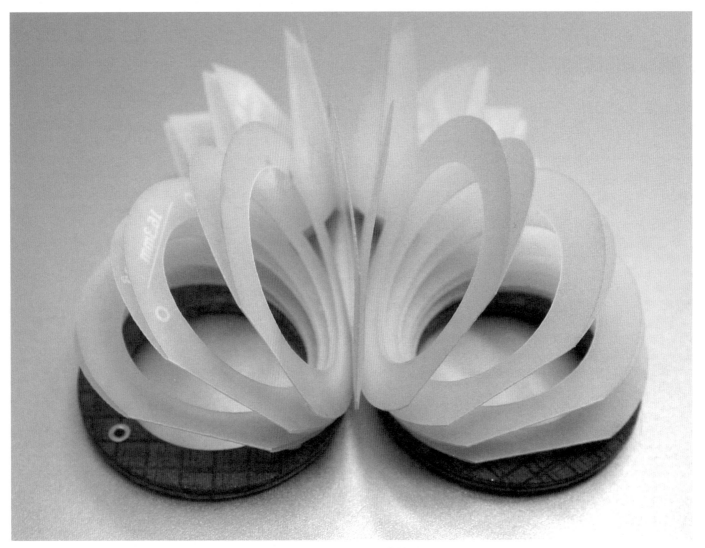

Heirlooms ring unfolded.

Throwing a pot and feeling the thickness of the clay throughout the making is a clear example within ceramics, but drawing comes under the same rule. 'Hands get shaped', wrote Malcolm McCullough in his book *Abstracting Craft*.[7] 'They may get callused or stained. They pick up experience.' Without this experience, this handling, how can we understand, anticipate or manipulate material behaviour?

The second conclusion is the result of a dialogue with science concerning the reduction in programming and processing stages between artist and machine. It is arguable that experience can be passed on to a machine by virtue of understanding it, maximizing its efficiency and so improving the final product; much like driving a car and getting to know it, or, as many of us have also experienced, like playing an instrument. These examples, however, place the person in direct contact with the object. Why, then, could the artist not be in more direct control of the laser beam? Furthermore, could it be made capable of translating variable pressure as does a pencil?

Any apparent freehand marking done by lasers is achieved by digitizing a drawing or diagram. This places the artist one step away from the process, but not from the purpose of the drawing. My proposal is that the currently used 'digitizing pen' could be used to link to a 'galvo' (galvanometer) head laser, allowing the artist to control the beam directly. The pen allows full movement on the x-y axis and the pressure-sensitive feature controls the depth of marking. This would represent a significant step forward in the 'humanizing' of a precise, digitally controlled technology. It may also go some way to ensuring the survival of drawing by hand.

Acknowledgements
Photographs: Jim Grainger

Thanks to Dr M. Schmidt (University of Manchester, LPRC) and Mr K Shoba (City College Manchester) for the support and help in the production of this jewellery.

Notes
1. Broers, A., *The Triumph of Technology,* Reith lectures, BBC Radio 4, 2005.
2. Kesseler, R., Harley, M, *Pollen. The Hidden Sexuality of Flowers',* London, Papadakis, 2004.
3. Cunningham, J, *Maker, Wearer, Viewer,* (exhibition of contemporary narrative European jewellery, The Glasgow School of Art, 2005).
4. Association for Contemporary Jewellery.
5. Professional Development Qualification, *In The Making,* City College Manchester / Arts Council North: exhibition at FAD (Fomento de Artes Decorativas, Barcelona, 2003).
6. Association for Contemporary Jewellery, *Heirlooms,* (membership exhibition, St. Botolph's Church, London 2006).
7. McCullough, M., *Abstracting Craft: The practiced Digital Hand,* Cambridge, MA, MIT Press, 1998, pp. 2.

4

REFLECTION ON TIME SPENT DRAWING: TOWARDS ANIMATING

Pat Gavin

It is more likely than not, if you live in the United Kingdom, that you have frequently seen Pat Gavin's work. His title sequences have graced our television and cinema screens for decades. Collaborators have included Dennis Potter and Ken Russell. Multiple BAFTA nominations have included awards perhaps most famously and memorably for *The South Bank Show* (1981 and 1984, innumerable sequences from 1978) and *Poirot* (1990, over 30 sequences).

Pat Gavin sets out one of his purposes for drawing as 'each time you start a new drawing it is in the hope of making a better drawing than the last one'. He shares with us, through a strong personal voice and sharp visual memory, a potted history of his drawing experiences and how these have helped develop the purpose of his drawing for work in moving image. Childhood attempts at drawing and memories, along with a dominant and potent imagination, help set the scene and illustrate vividly his passion for drawing and his early awareness of the transient quality of much drawing. Seeing time as a medium in drawing, Pat Gavin surmises that the fact that animation, indeed all moving image, has to 'stop' sets it apart from other forms of drawing, and alters its purpose. Adventures with technology in the early seventies and his eventual control of the digital technology now on offer demonstrate his pioneering attitude to the purpose and the application of his drawing across his phenomenal career.

Movement and motion have dominated his thinking about image making at all times. He uses drawing with a clear and defined purpose: to think, to work out, to develop and mould the character of the information displayed within a few moments on screen. Yet this rapidly absorbed information must contain the absolute essence of his intentions, even when others work on the same images. The atmosphere,

period and meaning must get through to us in a matter of seconds, or at most a few minutes, as we and millions of others settle comfortably to watch on screen fact and fiction, romance or thriller, mystery, comedy, progressive film or animation.

Drawing is one way of making sense of the visible world and also, as Paul Klee said, 'To make the invisible, visible,' but the purpose of drawing is quite simple – each time you start a new drawing it is in the hope of making a better drawing than the last one you did. Drawing and I go way back, it has been a part of my life and it has been how I have thought and formed opinions and has in a way played a big part in who I am. So my days are all about looking and seeing and being aware of ideas that can develop and resolve themselves as drawings. A complicated idea can be made very simple if you can get it on paper and see it.

I was an illustrator back in the 60s and I have always got the oils and brushes out in any spare moment. I love painting and drawing and many of my lasting memories have been to do with things that hang on the wall. But it seems to have been my lot to be involved with the moving image, and since I first saw Peter Pan and later a documentary about the making of Animal Farm, in which a grown man was looking in a mirror and pulling faces and shamelessly drawing himself as a pig, I thought, that's the job for me, and all these years later I can now understand why he was able to see himself as a pig. Animation is so labour intensive you become this kind of beast of burden, almost to the point that you would rather do anything other than put yourself through the pain. I would look at all the wonderful work by Degas and Schiele and Rembrandt and think how elegant their simple drawings were, how expressive of a single moment in time but also how that single moment implies other moments before and after that depicted, that in fact we can imagine a whole life of these people described and made real as a simple single drawing or painting. So I very often would ask myself, usually about three o'clock in the morning with still some hours to go before that last 'in-between time' would be finished, why do I do this rather than the static single piece. I eventually figured it out. There is a profound difference and the difference between static drawing and the moving drawings is that at some time the moving drawing has to stop. It has a kind of mortality. Whenever I watch an animated sequence I know that it has to come to an end and therein lies a tension that no static piece can have, This tension is, for me, the fundamental building block of any time based medium. Like in music or in theatre or, of course, the cinema, it is all about '...now that this thing has started, how will it end?' A painting on the other hand, when we all go home and the lights are turned out, will still be hanging on the wall, but the moving image has a short but very bright life that demands a different kind of understanding.

Drawing and Chris Pickesly are my two oldest friends; we grew up together and are now growing old together. The first time I was aware of drawing I would probably have been with Chris, we were in nursery class together and were inseparable. Each morning our teacher would draw on the blackboard nursery rhyme illustrations just like the ones we saw in the school books - Little Miss Muffets and Little Boy Blues - and realized that the book pictures were made by somebody, they didn't just come in books, and I would watch fascinated as these squiggles and lines in bright chalky colours became a recognizable world like my own, but then became magically

different. She would spend about ten minutes a day drawing and would tell the story as she drew (a bit of a Rolf Harris). But how these pictures revealed themselves to me over the ten minutes or so that it took to make them was the real wonderment. I remember it as a kind of animation. The figures in the scene were not animated but were full of life and seeing these smudges of colour become, through the medium of time, something recognizable was unimaginably exciting for me. And then at the end of the day just before we went home I would always dread the moment when she would rub out this glorious thing that I had been enjoying all day; a few quick moments with the blackboard rubber and the blackboard was just a blackboard again. As far as I know Chris was less concerned than me. I suppose his interests lay elsewhere, Chris would grow up liking geography, real places on real maps, but it was the drawn world of the imagination that would become my world.

I began drawing when I was still in the nursery class. Hating my feeble attempts, I would angrily rub with these so called coloured crayons that all looked so dark they were practically black, not like the bright colours on the blackboard. I would rub holes in the paper trying to get it right, I would go clear through to the desk trying to draw like my teacher, but I would just be told off for scribbling on the desk. I could not get anything right; the colours were all wrong and ugly and when I tried to copy what was on the blackboard, it always came out the same horrible scribble, time after time. It caused me deep depression. There was a real and profound need for me to be able to draw. Then one night in bed I was drawing on my bedroom wall, I drew a sea plane (I remember putting a letter box and knocker on the pilot's door). I also drew a pirate ship and a pirate and, like all the other kids at school, I drew the body as a circle and the head as a smaller circle and the arms and legs were the usual twigs, but then I realized something – people don't look like that, and so I drew another pirate next to the first one. This time his body was more of a triangular shape and I stopped and I knew that this was better. It was not right but I knew then that it was going to take time, but that at some time, one day, I would be able to get it right if I kept drawing.

Ever since those childhood days I have enjoyed drawing, enjoyed the challenge of drawing. I did not realize it then, but the time element was as important to me as the drawing. Then when I got interested in films at the Saturday morning children's film clubs and seeing all this moving excitement, I would rush home and try to make films by cutting up strips of paper the width of a piece of 35mm film and drawing the story frames of all my heroes; *Rocket Man, Superman, Captain Marvel,* and *The Purple Monster From Mars.* I would shine a torch through the drawings in the hope that somehow the light passing through them would bring them to life. It was not until Terry Jacobs (the big kid down the road) showed me how to do flicker books in the margins of old books that the penny dropped and I got a glimmer of understanding of just what was involved. I became obsessed with telling Flicker stories, epics such as; *Man Takes Dog for Walk; Man Bends to Tie His Shoe, Dog Bites Man, The End; Or Man Walking, Man Falls Down Man Hole, The End.* I did a gangster epic (I still have it) involving gang massacres, bank robberies scary car chases and the inevitable gangland death scene. This was in the margins of a book called *100 True Stories Stranger Than Fiction.* This all turned out to be good practice for when I went to work in television. When working on children's shows such as *Magpie,* I would be asked to illustrate stories and poems just like in *Jackanory* and

was forced to admit that still drawings are all right in books but on television they somehow looked wrong. They needed to move and so I went back to my old flick book days and attempted to make them move. Of course the first thing that occurred to me was how long it was going to take and for normal programme content budgets and schedules this was out of the question. But programme titles were another matter, so that was where I really started in earnest. One of my first jobs was with Janet Street Porter, the show was *The London Weekend Show*, the titles were about an obnoxious 'Yoof' who swaggered down urban streets like he owned them. He was a bit of a punk, although punks had not been invented then – not in fact until they first appeared on our show. (The director told me that the punks all liked the titles, but as I had just had a run-in with someone who turned out to be the one and only Sid Vicious earlier on in the day, I was not sure whether this was a good thing or not).

All these early title sequences were like going back to school, I always think of them as my 'student work', but after a few years of trying to learn the trade I became a good character animator. But I could not make a reasonable amount of money; not as much as I could make as an art director. This was very unsettling as was my drawing being ruined by constantly having to put it in this straight jacket called animation technique. It is essential for me when animating never to think of the drawing that I am working on as a 'Drawing'. I found that if I did, all kinds of interesting details in the single drawing became awkward visual blips when it was running at film speed. The subtlety of drawing that I liked, which was largely to do with texture, became an impossible logistical problem when multiplied by a factor of 24 frames per second (now 25 frames per second), so I found that I was becoming a victim of the process of animation. As much as I loved the great animators' drawings, I eventually realized that I did not want to draw like that. And the other problem for me was that, because you could not make the entire animation yourself, it was inevitable that it would largely be other people's work that would take over the screen not mine. Yes, I designed it, and would have keyed it out and directed it but the final work was by another hand, and marvellous work it was too – Jerry Hibbert, Dennis Sutton, Corrona 'The Countess' Esterhazy, (and she was a proper Countess too). The work that we were actually seeing on the screen was made by their hand not mine, and as brilliant as it was, the poetry was getting lost in the translation, and just as I was becoming disenfranchised with this wonderful but very unreasonable thing called animation, along came computers.

My first experience of the digital world was about 1972. There was a device at ITN which we hired for a day and I did some drawings directly on to the screen with a 'light pen', very crude but fascinating, but the penny did not drop that this could become the answer to the problem. Then in 1983 I went on a Quantel PaintBox course and I began to get a glimmer of an idea as to what may be possible. Here was a machine that allowed you to work directly with the television screen in a way that had not been possible before. Admittedly the line quality was not what I wanted but there was no translation and no third party between me, my work and the finished animation. I was solely responsible and suddenly I could design with the stuff that TV images are actually made up of: the pixels. The titles for *Poirot* were in fact the first real job that I carried out using PaintBox. Some of the work was actually done on another system – but all the

Mack the Knife.

concept work was thought out on *PaintBox* and the digital integrity of all my original 'drawings' was maintained on another system that eventually became Cambridge Systems Animo. In these early days (1988), the bit that made things move was achieved by hand in the old fashioned way, that is, three blokes in a room murdering the art of drawing all in the cause of animation to make complicated images link and move. What was still frustrating was the entire sequence was based on two paintings that I did in two days. Drawing is my short hand: essentially a quick procedure for getting lots of ideas out of my head before it explodes; the animation being, by total contrast, unimaginably slow. The *Poirot* titles were about 3 long months in the making.

Today, all the tools seem to be in place to enable the drawn moving image to become something truly of itself: the end product reflecting exactly the original concept and feeling. With packages like Painter and After Effects, I can explore ideas and techniques and story and I can draw in almost any style I want; possibly even my own. I have been accused of many things but originality was never one of them, and with this new cocktail of tools, who knows? I might even achieve that long-held idea to see with my own eyes a drawing move and reveal hidden ideas, stories and meanings, and still retain all its integrity as a drawing. And yes it will have to come to an end – the old projector will stop turning; the computer will go into sleep mode – but not too soon.

I had written a script called *The Threepenny Trial*, all about a court case between Bertolt Brecht and Kurt Weill, the authors of *The Threepenny Opera*, and Warner Brothers Films. It is about the song and dance that happened when they met as adversaries in a Berlin court over the film rights of *The Threepenny Opera*. It was to be a big all dancing, all singing, musical piece, but my first concern was the people and their lives in a world that was being torn apart by forces that would become the Second World War. So I made lots of images to bring it into some kind of focus for me. Not necessarily actual scenes from the script but something that would help me get the feel and taste and that might help others to get it as well. I began with one of the principal characters: Mack the Knife, I needed to see what Mack looked lik,e so I made several images of him. This was the first one, and it was not quite right.

This was based on a description by Brecht of Mack as some kind of insidious bureaucrat: his power is in his ability to control others; he is a sociopath with hardly any redeeming qualities at all; woman like his power but would never like him; he is incapable of love and of being loved. The image has been created via an early Soho memory (1961) when I saw this man being threatened by a couple of Maltese gangsters with stilettos, in broad day light on Old Compton Street. They towered over him but he showed only contempt for them. The scene was interrupted by police bells and the street emptied and I seemed to be the only one left when the police arrived. I scarpered fast.

We were talking to Sting, who was interested in playing the part of Mack. This is one of several images of him created in a manner relevant to the time and place that was Berlin in the late 1920s.

Mack the Knife 02.

Sting as Mack the Knife.

Threepenny Trial Bert and Kurt.

Threepenny Trial Mack and Polly.

Orpheus in the Underworld.

This helped me to work out how to shoot a two shot of Bert and Kurt that would capture the alienated character of their working relationship. Brecht was a bully but charming with it, but only when he got his way which is to say... he was always charming. Kurt was a very quiet studious chap who was somehow always overshadowed by Brecht. I am trying to indicate this by throwing Kurt in shadow while Brecht is always lit. Making images like these helped me to keep control of something that was always in danger of growing beyond my control in the creation of the characters.

An early look at a two shot of Mack the Knife and Polly Peachum. This a scene with the moon over Soho, a moment of almost love and tenderness for 'Mackie Messer' although he is still scheming and dreaming of murder.

This was a part of a possible music idea. The visual style is the same as *The Threepenny Trial*. It depicts the moment when Orpheus loses faith and starts to turn and look at Eurydice knowing that if he does she will be lost to him forever. Her tragedy is that she cannot stop him. Although this was the first stage of a commissioned artwork I still thought about it as film and set it, costumed it and cast it like a film. I saw the railway terminus at Union Station Kansas City in 1969 and the building left an indelible impression; the ideal place where the doomed lovers surface, at the end of the line!

5

DRAWING: A TOOL FOR DESIGNERS

Dr Russell Marshall

Russell Marshall is a Lecturer at Loughborough University in the Department of Design and Technology, with teaching responsibilities that include a range of topics within Engineering, Product and Industrial Design, such as: materials and processes, engineering drawing, design for manufacture and assembly, two and three dimensional computer-aided design (CAD) / computer-aided manufacturing (CAM) / computer-aided engineering (CAE), design ergonomics and human modelling.

His research interests are broad, including human modelling and tools and techniques for facilitating and empowering designers in human-centred design practice, the view of design to manufacture as a single process, including modular product design, Quality Function Deployment (QFD), design for manufacture and assembly, drawing and visualisation in 2D, 3D real and virtual media.

He has an ongoing role as principal developer of the software tools HADRIAN and SAMMIE.

He is a co-editor of *TRACEY*, Loughborough University's open access online journal for contemporary drawing research, and he has 7 years of experience in ergonomics consultancy, including work on anthropometry requirements for the Ministry of Defence (MOD), individual assessments of workplaces, vehicle evaluation for a range of car manufacturers, and tool development for ergonomics evaluations.

This diverse background of research and scholarly practice provides the platform for Russell Marshall to explore the relationship between drawing and design and, in particular, industrial design/ product design. He develops discussion concerning the requirements of taking

an initial idea and embodying that idea in forms of response. The purpose of drawing here is highlighted as a primary tool for design thinking where drawing is one of the many tools and techniques that have been adopted, adapted and developed by designers to support their responses.

Students: the future designer

The future designer is equipped with an array of tools and techniques to assist in the task of designing. The emphasis placed on tools and techniques is attributable to a number of factors. One of which, is the complexity of the task. Whilst at its most basic, design does not have to be complex; modern society almost demands a complex solution to most user needs. Increasing user demand, advances in technology, increasing legislation, all drive a more complex set of issues for the designer to manage. This complexity is one of the main contributors to why design is now largely a team exercise (Ulrich & Eppinger, 2003).[1] Different disciplines will be represented on the design team to lend their expertise to different areas of the design. However, the inclusion of multiple people in the process presents its own complexities, not the least of which is how thoughts, concepts, and concerns are communicated between people who possess different working languages. Engineering designers, industrial designers, product designers, marketing people, systems engineers, manufacturing engineers, management, and end users all have their own particular view of a design and will also have their own preconceptions, terminology and ways of working and contributing. In an attempt to support the process, to ensure all of these people can work together to achieve a successful outcome, tools and techniques have been developed for every possible design activity. Whilst future designers will be exposed to some of these tools and techniques, the most common tool taught, practiced and also most easily overlooked, is drawing.

Drawing for Designers

The main component of drawing teaching, and indeed practice, revolves around sketching by hand and what would be referred to as 'rendering', where rendering is used to refer to two dimensional techniques to facilitate explicit representations of form and surface. Almost all of this will be targeted at three dimensional forms to explore and communicate design ideas throughout a design process. In addition, drawing is used to help understand three dimensional forms and their relationship with two dimensional forms. This is a challenge both for teacher and student. The general approach is to cover a series of basic drawing and sketching practices that introduce and then build upon perspective, the construction of primitive shapes, techniques to 'plot' the path of an edge or surface, and the use of light and shadow. Irrespective of any discussion around the appropriateness of the approach taken, there are a number of interesting issues that arise even in this most basic of building blocks for future designers. A significant number of students are starting to abandon drawing by hand as early as possible in any design task in favour of a computer-supported alternative.

A technology push
The rapid development and general acceptance of computer technology has provided significant opportunities and also created tensions between the 'traditional' tools and methods and those supported by the new technologies. It is interesting to observe how students use technology such as Computer Aided Design (CAD) tools, irrespective of how they have been taught. This is not related to how they manipulate the tool in question but more related to when they use it and what they use it for. Clearly the freedom offered by manual sketching techniques is ideally suited to activities such as concept design. The exploration of ideas should be quick, often lacking in precise detail and should convey a breadth of influences and approaches. However, students will often jump very quickly to a computer supported tool, even at an early stage in a design process. They will then struggle with the constraints imposed upon them by the tool. Yet this is a conscious decision partly driven by the abilities of the tool but also driven by the ability to create clean, clear, accurate forms from the tool. An ability (they believe) they cannot match when drawing by hand. The tension arises from where the balance point lies between the speed of generating some simple geometry using a computer supported tool and the speed with which it can be done by hand. However, the balance has to take into account the ability of the computer to speed up subsequent operations (rendering, changing for variants etc.). So choice of drawing type then becomes a matter of efficiency.

Similar approach, different tool
There are similarities between working on paper and working with a CAD tool, however the approaches can also differ greatly and require a different mindset. Whilst the constrained environment of the CAD tool is there for very good reasons and often provides many benefits, it is fundamentally different from applying a line in a hand-drawn sketch with no constraints. Students often learn both manual and computer supported techniques in parallel reinforcing both the application of the techniques and also the general awareness of geometry.

In conveying why drawing is done in this manner it is important to look briefly at how it is done. One key approach in sketching three dimensional forms is 'crating'. This involves splitting the volume of the object to be drawn into a number of square or rectangular boxes. Depending on the form to be developed, the structure can be envisaged as a number of vertically linked horizontal sections or a number of horizontally linked vertical sections. This also assists with the relationship between two dimensional orthographic projections of three dimensional objects and three dimensional projections of three dimensional objects.

Predominantly, the initial crate structure is drawn in perspective; this makes it easier to ensure the resulting form also exhibits the correct perspective. In addition, the process also simplifies the construction of a form through partitioning the geometry into smaller more manageable sections and also emphasizes the positioning of planes of symmetry.

Using crating to construct
views of a three dimensional
object: courtesy of Ian Storer.
Loughborough University

Hand drawn crating and a CAD
sketch extruded into a solid model.

Whilst this approach has a number of benefits to the manual sketching of three dimensional forms, it also strengthens the links with computer-supported methods of generating three dimensional form. When using a parametric CAD tool such as Pro/ENGINEER (PTC, 2008),[2] forms are often generated by taking a two dimensional section and then performing some sort of operation on it to generate a three dimensional form. Thus an 'extrude' takes a two dimensional section, translates that two dimensional section in a third dimension to create a solid volume. For example, a cylinder is a circular two dimensional section translated in the third dimension.

Though the two processes bear little in common in practice, the generation of the initial two dimensional form requires drawing skills in both cases. The two dimensional form generated in Pro/E is usually developed in what they call sketcher, and is constructed using a number of constrained tools to link together a series of straight lines, circular arcs and spline curves to generate a form. Whilst there is significant freedom, none of the individual tools in sketcher could be truly called free form. With every step of laying down geometry the system records and imposes geometrical constraints, be they coordinate references for the end points of a line or the perpendicular or tangential relationships between two lines. No such constraints are imposed when sketching by hand; however, the importance and benefit that can be derived from such constraints are emphasized by the construction methodology of the crating technique.

Modelling in CAD in this manner is generally called solid-modelling. The forms generated through solid modelling are relatively simple (geometrically) and can be broken down into the simple two dimensional sections mentioned previously or common three dimensional primitive forms such as cubes, cylinders, spheres, cones etc. The alternative is called surface modelling and supports much more complex 'organic' three dimensional forms that would be very difficult to achieve using solid modelling. The approach for surface modellers is to use a series of curves to define a surface. Whilst the curves and associated surfaces are also constrained, as with solid modelling, developments have allowed a much more interactive approach to be taken to the drawing of the curves and also to subsequent manipulation of the surface. Curves can be drawn unconstrained through three dimensional space, constrained to a plane, or directly onto an existing surface. The surface generated by these curves can also be pulled and pushed about to generate the desired result in the same way a sculptor may play with clay. In fact, the freedom is so great that the tool also provides the ability to import photographs or hand sketched images to use as guides for the construction of the curves. Again this draws similarities with the hand sketching of curved geometry where the surface is constructed with a range of underlying curves or edges to both control the form but also help understand and communicate the form.

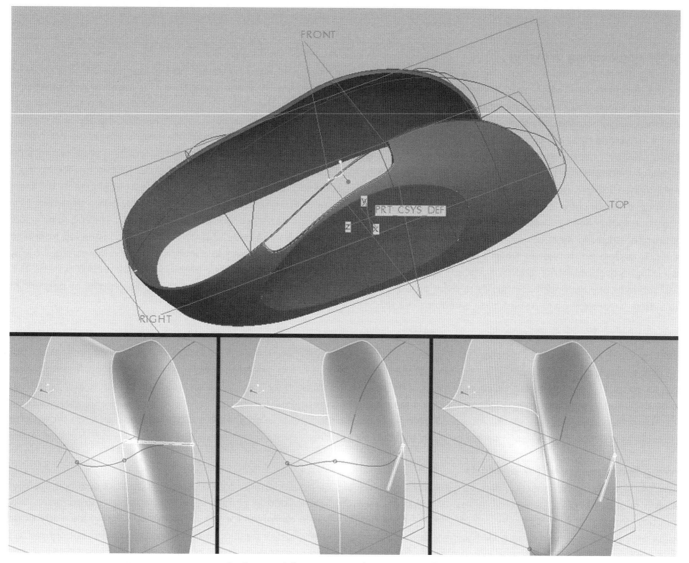

Surface modelling in CAD with interactive surfacing.

'Scruffy' engineering drawing

Engineering drawing is used to clearly, and without ambiguity, communicate information about a part or an assembly. It is an essential tool to the design that will often need to communicate what a part looks like, how it is made and how it fits together with other parts to other people, some of whom may never communicate with the designer in any other way. Engineering drawing is a good example of some of the issues discussed previously. Traditionally done by hand but increasingly done through CAD, it requires the ability to manipulate geometry in two and three dimensions. Engineering drawing also has some unique characteristics as it is governed by a standard, BS8888 (BS8888, 2006)[3] and, as such, is not open to interpretation, or personal style. One interesting element of teaching engineering drawing is how much emphasis is placed upon following the letter of the standard when creating drawings by hand and, in particular, the issue of line quality. Clarity is paramount and so the generation of an engineering drawing has to follow certain requirements for line style (continuous, dashed, chain etc.) and also weight (thick and thin), for which the standard even suggests appropriate thicknesses and a ratio of thick to thin lines. In addition, to achieve the desired clarity, an engineering drawing should possess certain qualities such as perpendicular edges to meet at a point (i.e. not overrun one another to form a small cross), for all lines to be constructed from a single clear mark, and so on. However, whilst it is important to be aware of this convention and to practice it when engineering drawing by hand, can it be overlooked, or at least made less of a priority, when the drawing will ultimately be produced by a CAD system? The use of CAD removes any issue with line quality and the appropriate use of line style, or worries about lines being parallel or perpendicular, as the system is constrained to ensure these standards are followed by default.

If we assume the vast majority of engineering drawing is, and will be in the future, done via CAD but that students still learn engineering drawing by hand, is it possible to practice 'scruffy' engineering drawing? Where the emphasis is on layout, on comprehension, but not on the skill of mark making? Clearly it is possible, but the end results are not engineering drawings. Many students find it particularly difficult to adapt to the engineering drawing mindset, setting aside the quick, dirty, freeform sketching mentality in favour of deliberate, calculated, planned mapping. These students welcome the opportunity to abandon one part of that process. They still have to plan, but can avoid the mundanity (as they see it) of the deliberate qualities of a recognizable engineering drawing. It has yet to be shown whether it is possible to practice 'scruffy' engineering drawing by hand successfully.

Drawing is not reserved for products

The use of drawing by designers is often targeted at objects, artefacts, products, but not exclusively. A second common area where drawing is employed by the designer, but less recognizably, is in ergonomics and in particular, human modelling. Ergonomics is a key area in any design that involves human interaction. A common difficulty is in designing for human interaction during the early stages of a design process, where the design is insufficiently developed to go to the effort of building a mock up and asking real people to try it out. This is where human modelling can play a part. It is basically a computer supported version of building a mock-up and getting people

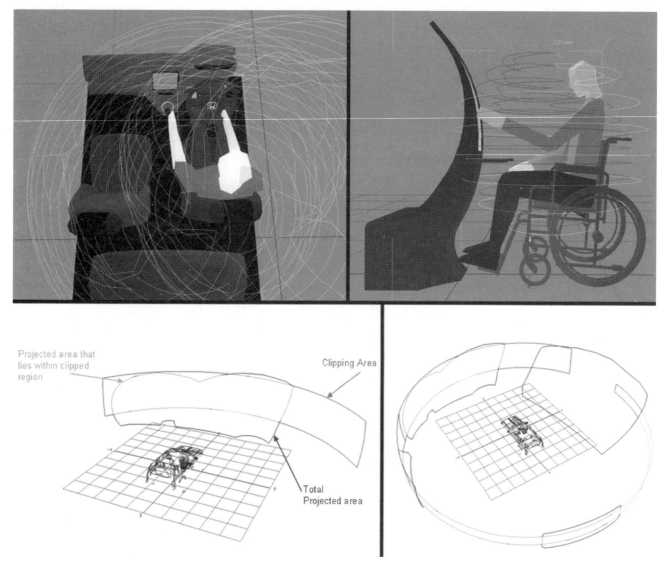

Drawings from various SAMMIE mapping tools: Reach contours on the top row and spherical projections of car window apertures on the bottom row.

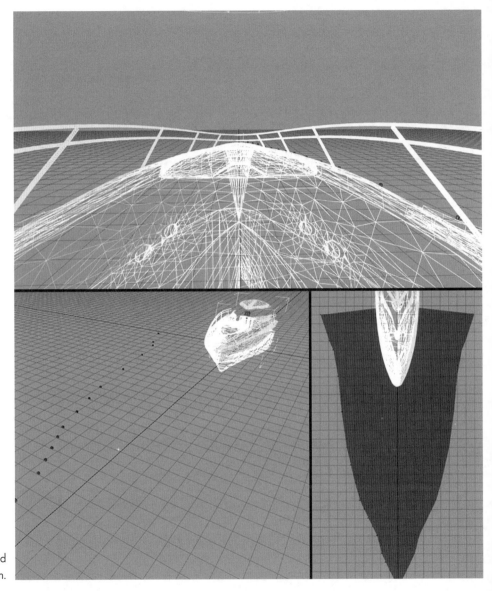

SAMMIE screen shots showing the cuboid
mapping process for a boat hull design.

to try it out. However, the mock-up is virtual, a CAD model, and the people are computer generated human manikins, sized and shaped to represent real people. SAMMIE is one such human modelling tool and this is used in teaching, but also has a long history of research and consultancy work in the design and evaluation of products and environments such as trains, cars, cranes, manufacturing facilities, cash dispensers, supermarket checkouts etc (SAMMIE, 2008).[4] Whilst little actual direct mark making is performed on screen, the tool is used to create many drawings both deliberately and accidentally in the course of an evaluation. Some of the most obvious drawings relate to the mapping of areas or volumes that represent some form of constraint either of reach or vision of a human. It is often useful to know a zone within which an individual can reach to inform where interaction points be optimally located. The same concept is also applied to vision. Tools are used to investigate the visual field from mirrors to investigate, for example, if passengers can be seen at the rear door of a bus from the driver's mirror, or to evaluate the general fields of view from vehicles.

In addition to the automatic generation of these maps, a pseudo map is often created to plot out more complex or obscure zones of interest. This is often done by posturing the human to generate a point that is then marked, often with a small cuboid, or by taking the view from the human's eyes and then shifting the marker around until it is barely visible. When done for many postures or around the perimeter of some structure or barrier, this effectively defines the desired zone.

This mapping process is purely a tool; the drawing is used to assist in an evaluative process. It is also intentional, efficient and highly effective. The drawing is also an effective communication medium. Being able to understand the limits of a human's capability with respect to a design is extremely useful, not just to the designer but also in conveying issues with existing designs to people who have responsibilities for their workers, or the public, who may have to operate in environments that have distinct ergonomic problems.

Manufacturing a drawing

All designers need to be aware of manufacturing issues, materials and processes, so that the design decisions they make can be realized. However, CAD systems can now be used to generate components directly through any one of a number of direct production techniques. These processes are highly automated; though often require some manual tweaking to be successful. A common technique used to produce parts from a CAD model is CNC (computer numerically controlled) machining (Luggen, 1994).[5] The part to be made is first envisaged as a block of raw material; paths are then generated to describe the direction a cutting tool should follow to remove raw material in order to generate the finished form. Often a number of these paths are created to complete the process, removing a smaller amount of material each time to define smooth curves or generate fine detail or surface finish. This drawing process creates an intricate set of two and three dimensional traces that represent elemental stages of a part's transformation to its finished state. As with many of the tools and techniques discussed, technology has played its part not only in enabling the process and the drawing, but also in changing its nature. So as we have discussed previously, what was once a very manual technique has become increasingly automated, with control, and to some extent creative freedom, replaced by efficiency.

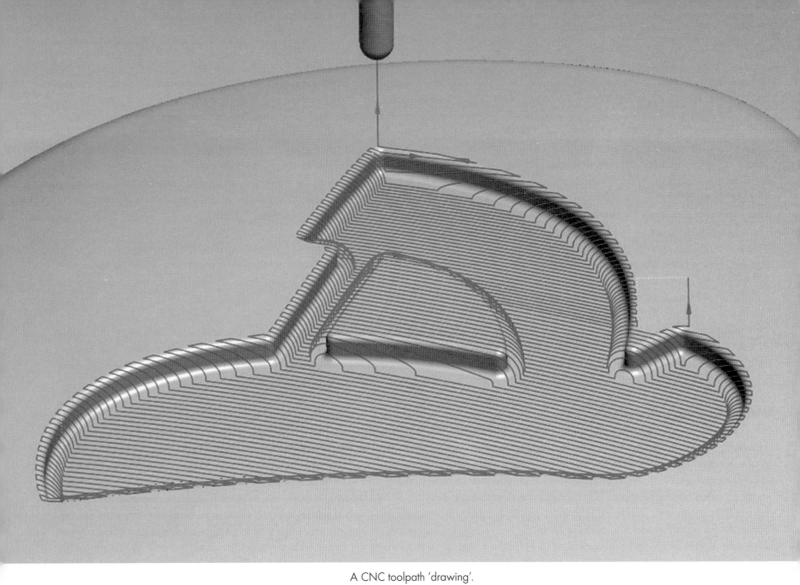

A CNC toolpath 'drawing'.

Drawing, the designer's tool of choice

Drawing is an integral part of design activity for students, educators, researchers, and practitioners. Primarily used as a tool, drawing lends itself to the generation of ideas, the communication of information, a link between the traditional drawing techniques and the newer computer supported processes, a means of understanding the three dimensionality of form, a way of mapping complex and often intangible elements of human interaction and also the generation of the building blocks of manufacturing processes. Advances in technology have introduced interesting challenges upon the users and teachers of drawing, and have also highlighted the issue of efficiency of the selected tool. However, these challenges have only served to highlight how important drawing is to all that those involved in design, regardless of how it is performed.

Notes

1. Ulrich, K.T. & S.D. Eppinger (2003) *Product design and development*, 3rd edn, Boston, Mass.: Irwin McGraw-Hill.
2. PTC (2008) *Parametric Technology Corporation*, [Online]. Available from: http://www.ptc.com/
3. BS8888 (2006) *Technical product specification (TPS) – Specification*, British Standards Institute.
4. SAMMIE (2008). *SAMMIECAD*, [Online] Available from: http://www.sammiecad.com/
5. Luggen, W.W. (1994). *Fundamentals of computer numerical control*, 3rd edn, New York: Delmar.

6

NONE, YET MANY PURPOSES IN MY WORKS

Lin Chuan-chu

Born in Wanli County of Taipei, Taiwan in 1963, Lin Chuan-chu graduated from the Fine Art Faculty (Chinese painting major) of the Chinese Cultural University Taipei in 1990. He completed a graduate certificate in Art History at the Fine Arts Academy of China in Beijing in 1991, and from 2000–2003 was a visiting artist in the School of Art Institute of Chicago. He graduated from the MFA in Interdisciplinary Arts at Goddard College, Vermont, USA in 2003. He now lives and works in Taipei, focusing on autographical themes to do with his upbringing in a farming family. He is a highly regarded contemporary ink painter and installation artist in Taiwan and has recently (2006) completed a residency at Red Gate in Beijing.

In answers to a series of questions,, Lin Chuan-chu discusses his creative process, with explicit reference to a body of work titled *Reading: Family Story*. Lin Chuan-chu is an artist who incorporates ink on paper specifically from the tradition of Chinese ink painting, arguably at the edges of drawing. He identifies a personal story of trauma, conflict and familial obligation. He simultaneously works with drawing, painting, writing, performance and video as an integrated process and so the particular emphasis on the purpose of drawing is often imbedded in references to any one and all of those activities. The format of an interview may offer a paradox in that, through conversation/dialogue, we arrive at a point where Lin Chuan-chu claims that his conversation with history and audience is a kind of silent conversation, achieved through gaze. It is never planned.

Q: Generally speaking, what is the purpose of your work?

A: I have barely thought about this question. This question is quite abstract and also quite broad for me. I grew up in countryside and teachers discovered that I had talent in literature and art when I was in elementary school. It was also true that I loved literature and art and they gradually became my career and part of my life.

As age adds up, the potentials of our lives seem to be decreased. For example, in my age now, I have no chance to become a lumberjack or pianist, so art possesses the main part of my life, which means that my life turns out to be different from others because of my practice in art, and it makes my life more unique, abundant and complete.

Q: Before 2000, your subject was landscape, so where did *Family Story* fit in your work?

A: The year 2000 was a turning point. I moved with my wife from Taipei to Chicago for her job. I thought it would offer me a good opportunity to experience western life and culture, but it did not work out very well. My son was only two years old. I had to take care of him, help him get used to the cold climate and the kindergarten programme. When he was sick, I became a 24/7 nurse. I really could not dive into a school or social circle like an international student or an artist. There were only fragments of time to paint. I felt isolated and anxious and noticed that I was not able to paint 'elegant' landscapes like before.

Only then did I realize that landscape painting is a very 'cultural' art form. When living in Asia, you can really feel the spirit of the forests, fog, mountains, and rivers. They assume any forms to fool your eyes because they bear mythic, symbolic and legendary characters. Although every once in a while we in Asia travel and sketch nature, we create landscape paintings out of the observation of nature and the meditating, the appreciation of ancient poetry and traditional paintings. This notion is very abstract, but this has been my way of painting landscapes. My techniques and artistic standards have been coming from this, the traditional East Asian way of drawing, ink painting.

What is the opposite word for 'cultural'? I do not know. Yet, in October 2001, I made a new series of drafts without a stop. None of them was landscape, but the scenes of me planting crops, threshing grains, and stories about my parents. I grew up in the rice field. Even during the summer and winter breaks from college (1986–1990), I was still helping my father with field work. That series of draft drawings reflected my experience in labour, land, and memories, which I had totally neglected in work prior to 2000.

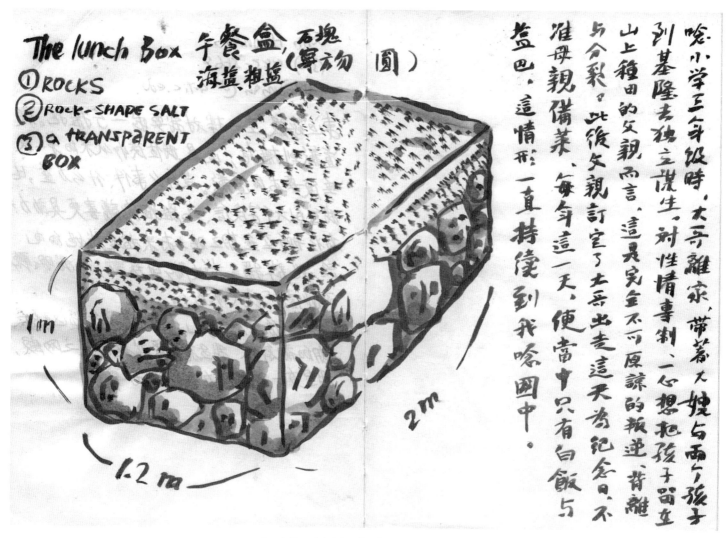

The lunch Box 午餐盒 石塊
① ROCKS 海藻、鵝藍（事物 圓）
② ROCK-SHAPE SALT
③ a TRANSPARENT
　　BOX

1m

1.2 m

2m

唸小学三、四年級時，大哥離家，帶著大娘与兩个孩子
到基隆去獨立謀生，對性情專制、一心想把孩子留在
山上種田的父親而言，這是完全不可原諒的叛逆、背離
与分裂？此後父親訂定了土哥出走這天為紀念日，不
准母親備業，每年這一天，便當中只有白飯与
盐巴，這情形一直持續到我唸國中。

Lunch Box. Ink. Note book, 22x31cm, 2002.

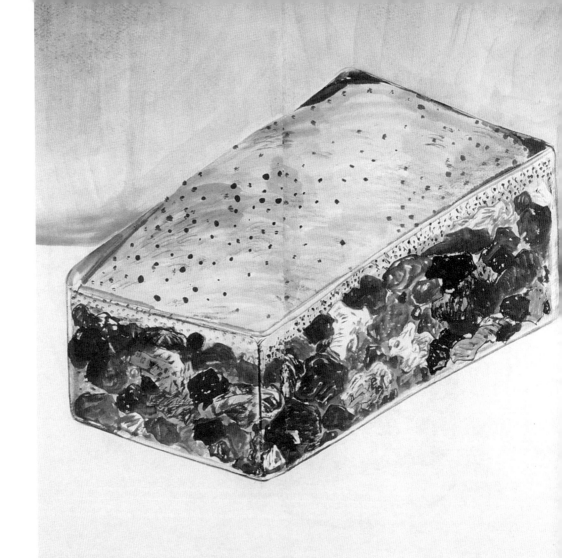

Lunch Box. Ink. Rice paper, 207x190cm, 2002.

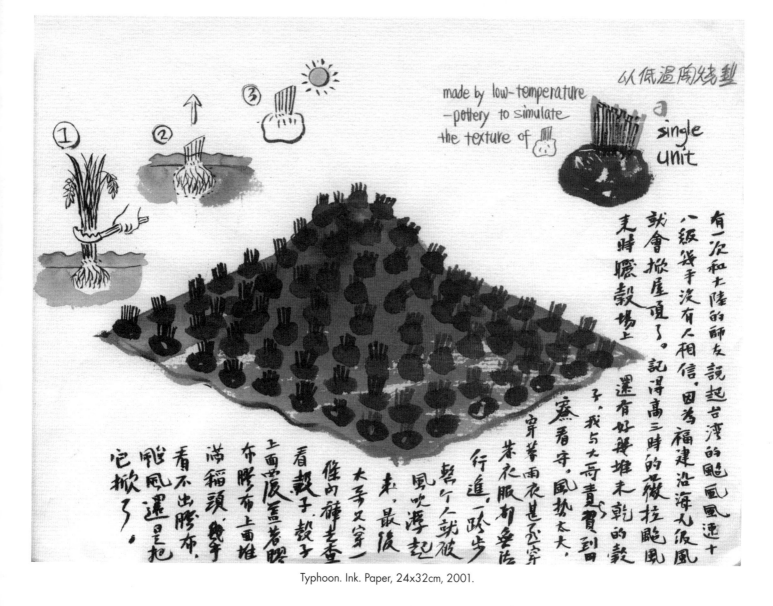

①

②

③

以低溫陶燒製

made by low-temperature
-pottery to simulate
the texture of

single
unit

有一次和大陸的師友，說起台灣的颱風風速十

八級幾乎沒有人相信，因為福建沿海九級風

就會掀屋頂了。記得高三時的薇拉颱風

來時曬穀場上還有好幾堆未乾的穀

子，我與大哥責任到曬

穀看守，風勢太大，

穿著雨衣甚至寸步

茶衣服都無法

行進，一跨步

風吹浮起

來，最後

大哥又穿一

條的種子香

看穀子穀子

亦膠布上面堆

滿稻頭，幾乎

看不出膠布，

颱風還是把

它掀了。

Typhoon. Ink. Paper, 24x32cm, 2001.

Q: So the purpose of your works is to express the two sides of your background?

A: Yes. But it was done unintentionally. The 'cultural' side – my landscape paintings – comes from my education, from outside. After the government of the Republic of China retreated to Taiwan, the Movement of Chinese Culture Renaissance during the 1970s was used for fighting Mao Zedong's abuse of Chinese traditional culture during the Chinese Culture Revolution in China. I received my education just during that period. It provided me with deep understanding of traditional Chinese calligraphy, painting, poetry and literature. I meditated through the history and culture, so painting landscapes is like sitting quietly and travelling through time to let my feelings come together with nature, culture, and history.

On the contrary, creating the *Family Story Series* was like having a fever. It came out from inside to outside, as if from a tangible angle to find out who I really am, how my life was, and what had been happening to me.

Q: So your purpose is to distinguish your two lives, two characters?

A: Yes. It was all about my educational background and my family background. I was both a literati and a peasant. The 'cultural' landscapes and 'empirical' family stories are completely different. This difference even makes me uncomfortable sometimes. You can find this same situation in V.S. Naipaul's autobiographical novel *The Enigma of Arrival*.[1] He is a well-educated writer who studied at a first rate university in Britain and inherited an affluent heritage from traditional cultures, but he is also a sombre and insecure 'indigenous' Indo-Trinidadian. He spent a long time mending the rupture between writer and human being and facing the trauma and influence brought about by this rupture.

From another aspect my peasant background and intellectual background sometimes benefit from each other. As I have touched upon in other articles, my peasant life helps me deeply comprehend the spirit of Chinese idyll and landscape paintings. At the same time, my intellectual life adds rich layers and implications of metaphors and symbols into the rural themes of my work.

Q: Is your practice the same as Naipaul's, serving as a retrospective self-therapy?

A: I think that many autobiographical works serve the purpose of personal therapy, although I don't know its result. Sometimes when we dare to face something, it does not necessarily mean that we can solve the problem or defeat it. There is no doubt that artistic creation provides a way of recognizing ourselves, sublimating sentiments and expressing our hearts. It is a kind of therapy.

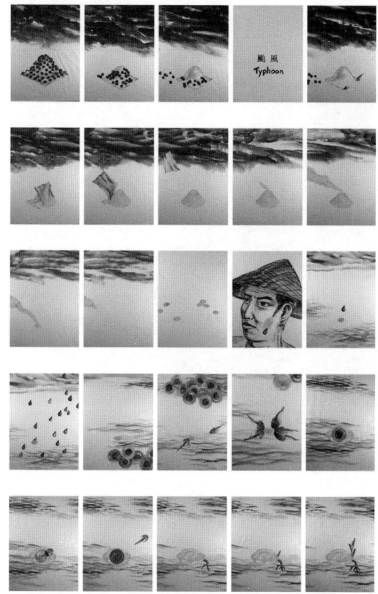

Typhoon. Ink painting, animation, 5' 00", 2004.

Grains. Oil on canvas, 150x150cm, 2006.

① H:5m

②

③ W:3.5m

1/1 bamboo

a single unit
of hay tuft

a single unit
of rack board

Father. Ink. Paper, 24x32cm, 2001.

Q: You said that you 'unintentionally' revealed your background. What did you bring out intentionally?

A: Chinese Song Dynasty litterateur Su Shi (Su Dongpo) once compared writing as gushing spring water. It rushes out from the earth without a choice. My work is just like that. I follow my feeling, my intuition and my inner needs. Once they come into the form of a sketch or a plan, I then invest all energy into its format until it is completed. The planning stage is very sentimental, while the implementing stage is very rational. But during this process of implementation I also try to be guided by intuition and randomness, so to make the work more interesting, more unpredictable, not completely in my control.

Q: Are you a teleologist? Is it more about completing a piece of work than creating it with a process?

A: Looking from the outside, yes. The artwork is like a container. It carries the artist's sensation and ideas. Only after this container is finished, can we explore the inner side of the artist.

But there is one thing that calls our attention. Before western civilization was systematically introduced to China, the dichotomy of 'content' and 'form' did not exist in Chinese aesthetics. They were a unity. This very concept helps me establish a belief, which is that the form of every stroke can contain individuality, sentiment, and intentions. Whenever I finish a piece of work and suffice the 'purpose', I feel that have actually completely the 'process'. They are also a unity.

Q: What exactly have the *Family Story Series* represented?

A: These series tell my family stories through objects (such as *Lunch Box*) and the spaces (like *The Barn*) in my memories. Some stories such as the *Threshing Field* are praising nature and the harvest, but most of the stories are tragedies. *Lunch Box* tells this story: In 1973, my older brother left home for a city job against my father's will. Since then my father set that day as an 'anniversary'. The whole family had to only eat rice and salt on that day. Even our lunch boxes were not exempted. To open such a tragic lunch box in school was very embarrassing for me. But I think the saddest person was my mother, because she felt this in the morning during the preparation of the meals.

Q: Your father is an autocrat?

A: Yes. I use a half-done hay stack to represent my father. He is like the piece of bamboo that stands in the centre of the hay stack. He is the gravity of the structure. The huge body of the hay stack (other family members) do not have any structural power.

Father. Ink. Rice paper, 302x190cm, 2002.

Actually, autarchy and patriarchy are typical problems in Asian countries. From a broader point of view, it is also the most typical social problem of Chinese culture.

Q: What forms did you use to carry out the *Family Stories*?

A: Besides drawing and painting, there are written texts, ink painting animation, sculpture, video installation and performative photography.

Q: Did you learn these art forms from contemporary western art?

A: I was enrolled in the residency program of the Goddard College in Vermont and majored in Interdisciplinary Arts from 2001 to 2003. That programme was like a mirror, in which I saw myself. Before I went to the USA, I had published five books and had several solo exhibitions. That means I had already established my literati background. All the art forms I have gone into, such as calligraphy, painting, poetry, theatre, *Qin* (musical instrument), martial art, and *Zen*, includes most of the western interdisciplinary art forms: drama, movement, text, sound, and visual arts. These five forms did not exist individually for traditional literati in China, but as one form. This understanding and self-discovery played the role of a mirror in helping me find the things that can be used in contemporary art, so I am able to use different forms freely and bind them together with a story that engenders internal relationships within them.

Q: How are your works received in Taiwan?

A: Let me give you two examples. One is Tunghai University art history professor Philip Wu's comment. He says that my *Family Story Series* have created a system for the 'moderate/personal history' of ink painting. Since during the 1200-year long history of ink painting, there were only elegant and idealized 'magnificent history' paintings. There was barely anyone dealing with personal family stories, especially tragedies, anxiety, or tension. Another opinion comes from Mr. Ni Zai Tsin, the former president of the National Taiwan Museum of Fine Arts. He thinks that my art does not follow any trend, but my own artistic ideology, which is the best response to globalization as a Taiwanese artist.

Q: If you agree with these two people, does it mean that dialogue with history and with the world is the purpose of your work?

A: Of course. But my conversation is a kind of silent conversation. It is achieved through gaze rather than arguing. And this conversation does not exist until I finish my work. It is never planned ahead of time.

As a matter of fact, there is criticism in Mr. Ni's comments. Most of the artists living in a marginal place such as Taiwan are studying the most avant-garde western art to catch up with global trends and to avoid losing a chance. However, I am nothing like that. I insist on keeping personal, regional, and finding an appropriate form. I hope that my role in globalization is a resource provider rather than a consumer.

Again, oriental art is old, complete, and well-developed. Yet, I hope that on its basis, my art can proceed with an essence that is contemporary. My ink painting animations and large scale works are meant to revive and enrich the thousand-year-old ancient materials into new art.

Note
1. Naipaul, V.S (1987) The Enigma of Arrival, London: Viking Press.

7

INFORMATION WITHOUT LANGUAGE

Nigel Holmes

Nigel Holmes works in the delivery of information through graphic design. He graduated from the Royal College of Art in 1966, and worked in England until 1977 when Walter Bernard hired him to work at *Time* Magazine in New York. As Graphics Director of *Time* magazine, his pictorial explanations of complex subjects gained him many imitators and a few academic enemies. But he remains committed to the power of pictures and humour to help readers understand abstract and difficult scientific, numerical and informational concepts.

After sixteen years, *Time* magazine gave him a sabbatical and he never went back. Now he has his own company which has explained things to and for a wide variety of clients such as Apple, Fortune, Nike, Sony and Visa. He continues to make graphics for publications such as *The New Yorker, Harpers* and *The New York Times*. He has written four books on aspects of information design. With his son, Rowland he produces short animated films.

Nigel Holmes asks us to consider that today's diagram makers are like the cave painters of 32,000 years ago. He explains that both are drawing ideas and that the purpose of diagrams is to explain. The difference between then and now is that today we have a verbal language and that (most) modern diagramming is based on language structure, and that drawing is the basis of all diagram creation. He introduces Otto Neurath and Gerd Arntz and their pioneering work in the field of information graphics in the 1930s. He asks us to consider that there is a gap between seeing and drawing. Sometimes the gap is momentary, sometimes much longer, however in both cases we are drawing from memory. He proposes that the artists in the caves were drawing from memory, sophisticated observations, held in the mind until they are reproduced in the caves, and that the same is true today: designers and artists who make explanatory

diagrams are seldom looking at something as they draw their diagrams. They are creating images from memory, often reusing icons from their own personal vocabulary.

Before spoken and written language, there was gesture.

Eventually those gestures were made graphic: they were scratched or painted onto a rock surface to make their intention permanent. What can we make of man's first drawings (or at least the earliest so far to be carbon-dated) from 32,000 years ago? What were cro-magnon men and women doing in the Chauvet caves, in France?

Today what they scratched and painted is called art, but I wonder if the creation of art really was what was on their minds. While we marvel at the sophistication, the colour, the beauty and the clever positioning of the images (so that they might appear to emerge from a crack in the rock surface, for instance), we can only speculate about their meaning or purpose.

Scientists and other experts have suggested that cave paintings were the result of elders teaching others about animals they might encounter inside or outside the caves; that they were warnings to beware of dangerous animals; perhaps they were a simple inventory of animals seen, or a visual accounting of animals killed. Were the drawn animals to be used for target practice inside the cave? Was it reverence for animals as sacred beings (horses, particularly) or hierarchies of animal importance? In the case of non-animal imagery, some of the drawing look like erotica or perhaps sex education. It's interesting to note that the cave dwellers hardly ever drew reindeer and salmon – their staple diet. Although these animals were plentiful in nature, they only very occasionally appear on the walls.

Perhaps cavemen were just passing the time in cold winters. Perhaps they were simply decorating their walls. Unless we do consider cave paintings to be mindless doodling, most of the experts' speculations point to a conclusion that the paintings were meaningful diagrams or instructions, not art for art's sake.

In addition to these guesses about motives, we don't know whether the painters spoke to each other or not. If there was language – some scientists think there might have been unstructured sounds and clicks – it was not written down. In that case, these were wordless diagrams – that is, they were not illustrating or accompanying a text – and that's a form of graphic design that's in use today, enabling us to cross international language barriers. Think about the directional way-finding in airports, or assembling a piece of furniture from a kit with a set of visual instructions.

How to carve a turkey, Wordless Diagrams, Nigel Holmes, 2005.

How to do a reverse inward pike dive, Wordless Diagrams, Nigel Holmes, 2005.

Today's diagram makers are like the cave painters in this sense: both use drawings to explain history, ideas, and the world around them. But if the designers who draw instructional diagrams today are the modern equivalents of the Lascaux, Altimira and Chauvet cave painters of 16,000 to 32,000 years ago, there is a difference. Today, there is spoken and written language, and most modern diagramming is based on that language structure: graphic artists make step-by-step diagrams that tell stories in a logical sequence, like pictorial sentences. They use a visual alphabet to explain the world. It's a global language that anyone can see, but one that no one has to *read*.

It is precisely the lack of structure in cave images that makes it hard for us to decipher their meaning, and that is why we resort to the inadequate word 'art' to describe them. 'Art' does not properly describe the muddle of images we see in the caves: animals overlapping one another, as though over the years one generation of artists after another had complete disregard for what was already on the rock surface. Cave art is much more like pages from a very big sketchbook: something that was being privately worked out or being demonstrated to others, perhaps to many generations – after all, they were created over a period of 20,000 years.

The search for their meaning will go on. As a diagram designer myself, I see tentative starts and finished sequences in the muddle of drawings on the cave walls. These are the beginnings of visual instructions.

A pioneer in structured, wordless diagrams is Otto Neurath, an Austrian social scientist who, in the 1930s, together with graphic artist Gerd Arntz, revolutionized the field that is now called information graphics. Neurath's ISOTYPE (International System of Typographic Education) was successful for two reasons: firstly because of Neurath's own clear thinking about which facts and statistics were important to show, and, secondly, because of the immaculate drawings that Arntz did to make those statistics visible. The drawings were simple and iconic but they were beautiful. Just like the images from 32,000 years ago, Arntz's drawings were not literal; they were based on good observation, reduced to a few lines or shapes that captured the essence of whatever was being drawn. Arntz generally followed Neurath's theory that the most recognizable view of an object or animal was its silhouette. Neurath had argued that there was a kind of dispassionate, scientific authority to the silhouette, as though it were a shadow of the real thing cast on paper (or the walls of a cave). By making little silhouettes of cars, houses, horses, soldiers, guns – any commodity or object, in fact – Neurath's team compiled a vocabulary of icons that enabled the team members to build statistical pictures and diagrams of the world at that time. Arntz's moveable and interchangeable icons were as great a step towards visual understanding as Gutenberg's moveable and interchangeable pieces of type were to the development of reading for the masses.

The purpose of diagrams, whether in caves or in modern media is to explain. And drawing is the basis of all diagram creation. We draw to understand; we draw to clarify. Drawing teaches us to see the essence of things, not just the surface appearance.

Three icons by Gerd Arntz, redrawn from the originals for clarity.

But there is a gap between seeing and drawing. When we draw, we look first at what's there, and then we turn our heads away from it to actually do the drawing. So at the moment that an artist tries to represent something by drawing it, he or she is not actually looking at the thing, but rather at a blank sheet of paper (or a blank stretch of rock). The gap between seeing something and drawing it can be short – those momentary glances up and down from object or landscape to the paper in front of us – and we call this activity drawing from life. Or the gap can be long – an hour, a week, a winter – and we call this drawing from memory.

Clearly, the artists in the caves were drawing from memory. That fact alone makes their pictures all the more remarkable. Any thoughts that these were primitive scribbles are wrong; they are sophisticated observations, kept in the mind from seeing the animals in the wild, until they were reproduced in the caves. The same is true today: designers and artists who make explanatory diagrams are seldom looking at something as they draw their diagrams. They are not drawing from life; they are creating symbolic images from memory, often reusing icons from their own personal vocabulary. In time, that personal vocabulary becomes recognized as the artist's style.

A brief word about style: neither the cavemen nor modern diagram artists attempt to make realistic photographic images. 32,000 years ago, the concept of a photographic likeness did not exist. Nowadays, there's no point in emulating a photo. Cameras do that. In between these two time periods (or more precisely, from the middle ages to about 1825) artists did strive to make images as realistic as possible, but once photography was invented, they stopped and went back to making primitive, impressionistic, and eventually abstract representations of the world. (The English artist J.M.W.Turner is reputed to have said 'our profession is gone,' when he saw a daguerreotype for the first time.) Small pockets of painted photographic realism (and huge buckets of computer-generated realism) do remain – artists demonstrating their technical, if cold and artless, skills.

But the idea of a realistic, if not photographic, type of representation lingers in the mind of the general public, and it is fun to go to the site of a famous painting to check up on an artist s vision of it. Many people have visited the places where Cézanne painted and drew the Mont St Victoire, to see if his pictures differ from what s actually there. It is human nature for those who don t draw to think that to be a good artist you should 'get it right', meaning that the drawn result should mirror the view. However, that's not the purpose of most drawing, and certainly not diagrammatic drawing. When as you, as an artist, realize that the drawing you are making always takes over as an object in its own right, divorced from the scene or object being drawn, you know that it doesn't matter if someone comes back later to check up on your pictorial recording skills. The drawing is what matters. That is what remains, long after you have left the scene. That is what remained for generations of cave dwellers to see and to learn from.

In the 1960s, while I was at the Royal College of Art, our drawing teacher, Paul Hogarth, took a group of students to Amsterdam to draw. Paul was a successful practicing illustrator, and he sat down with us to draw the buildings in the central canal district. But he didn't draw

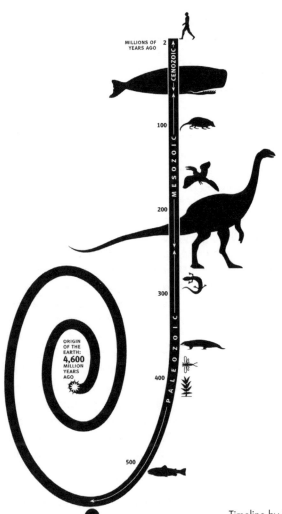

MILLIONS OF
YEARS AGO

2

100

200

300

400

500

CENOZOIC

MESOZOIC

PALEOZOIC

ORIGIN
OF THE
EARTH:
4,600
MILLION
YEARS
AGO

what was directly in front of him. He rearranged the scene to suit the picture he wanted to make; one that was more telling than a literal snapshot. In the end however, what he produced was undeniably a true picture of the place. Seeing him do this live taught me that, when drawing, what you are left with on the paper matters more than a 'faithful' copy of the scene. Hogarth drew the essence of the place, in the same way that Arntz drew the essence of horses, houses and guns for his icons and just as the cave artists drew their horses and mammoths. And even though Hogarth's work may be called art, and Arntz's called information graphics, they start from the same point of view – good observation.

The drawings in the Chauvet caves start from that point, too. The cave painters looked at the animals outside their caves then drew their versions of the animals to teach others. They were the first diagram designers. Their approach to drawing – observation and then simplification – and their reasons for making the drawings is the same for designers today. For us to have a connection to drawing as old as that is sobering and wonderful.

Now look at this simplified diagrammatic timeline of animal life on earth: at this scale, the 32,000 years between the cavemen and us cannot be differentiated. In the larger picture of life, we are the same people.

Timeline by Nigel Holmes.

8

LANDSCAPE – DRAWING – DRAWING – LANDSCAPE

Susan Hale Kemenyffy

Susan Hale Kemenyffy is based in the USA. She was awarded BFA Printmaking from Syracuse University, New York and has an MA and MFA Printmaking from the University of Iowa. She is widely published, lectures and exhibits extensively internationally and is involved in community projects around the use and influence of landscape in our lives. She has work in collections in the Smithsonian Institution, Washington D.C, the Philadelphia Museum of Art, Cincinnati Art Museum, Ohio, and The Carnegie Museum, Pittsburgh, PA, amongst many others including numerous private collections. Susan Kemenyffy has been Chair Pennsylvania Council on the Arts, 1997–01, Chair Emeritus of Pennsylvania Council on the Arts 2001–03 and Chair Advisory Council Erie Community Foundation 2006–08.

In her essay Susan Kemenyffy writes from the position of an 'artist-gardener'. Her view is that landscape, whether built or natural, is generally large and complex. She believes it is imperative that the artist and designer work to clarify the essence and context of each of their encounters with landscape. That by mindfully co-opting the legitimate and disparate skills, talents, tools and equipment necessary, they make their contribution to the collaboration that results in landscape design. Susan Kemenyffy believes that drawing can and does connect separate communities and levels of awareness and understanding. She describes drawing as an ephemeral concept that can emerge in any medium, to any purpose, in any scale (intimate to spacious), using disparate (ancient to ethereal – recognised to unknown) 'tools' in order to consider and resolve specific ideas and projects. Her style is almost stream-of-consciousness, raising many questions in a form of poetic writing that refers to the tradition of ekphrasis for its structure and style.

If landscape is an expanse of scenery that can be seen in a single view, then what vantage point most comprehensively observes that view? With what peripheral precision does one stand – without, within, above, below? Does the landscape include the sky? Certainly it

Beech along the lady pools.

London sketch book, Victorian and Albert Museum.

must, for is not the sky integral to our perception of the earth – the horizon line the connector? Is the 'view' part of history's immutable timeline, or has its nature been edited, or, alternatively, been entirely conceived by mortal minds – a built environment? Is its context a public outer world or does it lie in a private enclave? Is landscape a plinth, upon which an 'idea' appears, to engross, challenge, disconcert, charm the initiate, or does its mentoring allegiance spring from a greater context of eternal ebb & flow?

If drawing is the representation on a surface by means of line', whose surface, whose choice of lines? Does line speak to function – serviceable guide or marker, or does it present a simple unfettered will to create? Is it a combination of the two? Is the drawing purposeful or surprising?

How important is time? Is there an instant beyond which the thought is lost? Is its lifeline temporary, or has provision been made for sustainability? Is the manipulation of facile change paramount or subsidiary? Is the drawing a singular statement, or is it one advancing a thesis whose premise builds with perspective & progression? Is change an important ingredient in either approach? To what degree must maintenance preserve integrity? Is the drawing meant to be intimate or grand in size and scale? Is it passive or declarative? Is it individual, presenting a personal perspective – narrative commentary upon shared human reflections – or communal, tuning radar into universal imbroglios?

When wedding the two, landscape to drawing or drawing to landscape, which practitioner, horticulturist, designer, artist, gardener, is dominant, which is subordinate? Can they comfortably collaborate, articulating a cohesive vision? What is to be achieved? What is the intent and purpose of the 'adventure'. What senses are to be engaged? What is the anticipated tone of the encounter? Is it scripted or accidental? Is it captive or incidental? Is the artist's palette to be organic, inorganic or a combination thereof? What are the tools and materials to be used? How will they be deployed? Is the creation 'journey' more, less, or equally as important as the 'destination'? Who are the players and underwriters that support the enterprise, and what is their expertise? Who will be the audience? What is the physical and economic effort needed to capture the idea? If one pays for the anticipated pleasure, are there different expectations as to the nature of the encounter? If chance stumbles upon the unexpected, do we comprehend it differently if we have not paid to view it or know its cost? Does one learn more from confrontation or continual, gradual exposure? Knowing the effort, teamwork, expense of a drawing available only on opening night and in secondary source images, is there a moment when other factors weigh in? One plants trees for one's grandchildren, could the same be said for the maturation of landscape drawing concepts? Neither one nor the other is champion. Is it a 'but for a moment in this magical place' moment in time experience, or is it meant to harness other dualities?

Hidden rock bamboo.

How important is the embroidery of memory – what stature has the curled edges of deceit and wistfulness? How tall must reality stand to attention? Despite and because of shifts in materials, scale, and mortality – how does the world note the difference between statement and desecration?

With their abrupt disappearance, axiomatic drawings woven casually into the cues of daily life can unexpectedly create powerful messages, branding and searing history into memory. With the concept of, 'bring all the planes down', supernal contrails dissipated without replacement across a continent. Ethereal white slashes whorl away into dry air, or living longer, flow as crystalline strokes in moisture lengthening bravura, stop precipitously. In one moment, kilometre long strokes were speaking of energy, opportunity, and process. In the next, they are replaced with a tumbling emptiness, a shuddering stillness – a landscape drawing suddenly, irrevocably riddled with uncertain emotional and political implications.

Shift from contemporary time to Bronze Age time. Stand in Oxfordshire at a respectful viewing distance from the Chalk Downs and the graceful drawing of the Uffington Horse. The palpable silence of history can give no definitive answers, only suppositions, as to why that drawing exists in that place. Cared for through millennia, its milky clarity is now a certainty, vouchsafed by the National Trust. Because original intent and social context are lost, that does not preclude admiration outside the crutch of accepted conventional wisdom. Though the gliding horse has entered a more humble realm, it remains an elegant symbol, harnessing ancient energy, thought and hard work, within a land-canvas not ungrateful for its presence. Musing peoples, now bereft of its specific ideology, can only bow their heads in wonder.

Whether the creator is a singular high-flying machine leaving its footprint in the stratosphere or multiple trench-digging toilers back filling with chalk, to what extent does anonymity shape perceptions of inadvertent creativity beyond function? Must one always possess knowledge of 'other' in order to successfully comprehend the nuances of the art? What part does identity, provenance, and certitude play in appreciation? Is the sober embrace of those landscapes (the earth/sky surfaces) reduced or enhanced without their contrails or that amazing steed?

In the vast stillness of Colorado's Great Plains, where landscape serves as lieutenant to the sky, there is no need of you and me. Calm strength resides – complete, beyond correction – defying addition or deletion. There exist two drawings upon that land; one more ephemeral than the other. One comes as nature wills; the other goes as human need demands. One explodes periodically with the unexpectedness of accident or anger, in searing concentrations of power, molten in ferocity, intimidating in guileless summer's nights. Lightning, incandescent, rips the fabric of the sky, in dangerous drawings so magnificent applause is an indrawn breath.

Landscape drawing marooned bridge.

The other drawing, seemingly mundane in presentation, forged by adventure, later crafted by surveyors, engineers, and builders, spans the earth from yesterday to tomorrow. Is it not pikes, roads and highways which are the ultimate drawing upon the public landscape? With the sometimes guiding, graphic addenda of white lines, yellow lines, broken lines, do they not gird the earth to ease connection?

In their seemingly effortless utility, are they not a paean to the fundamental definition of drawing? Within the totality of earth's vistas, do they not appear as slender, fragile threads, delicate to the point of oblivion? Though drawn with earth, gravel, asphalt and cement, do they not personify distance subsumed by speed? Bound sensibly to topography, yet can they not be seen hurtling across mountains and rivers as spring hurries to exchange winter's 'set', and fog, the painter, temporarily checkmates the draftsman's line? Conceived as a means to organize and cross distances, facilitate trade, telescope movement and expedite efficiency, it was enough to be firm and lead safely – aesthetics were a world away.

Segue to the High Plains of hill country Montana, fast approaching Calgary, Alberta. The combines have come to perform an annual ritual. It is their season to harvest bounty from the land. Seemingly painted fields have given treasure. But though the gold is gone, replaced by undulating striped hills, their unintended beauty lingers. No skilled visual practitioners dreamed those images, but experienced, pragmatic, scientific agriculture did create them. Their pure geometry of line, so unlike the lush golden rapeseed fields of Central Europe, are a gross sibling to the cosseted stripes of Vita Sackville West and Harold Nicholson's *Tower Lawn* at Sissinghurst. Within the dichotomy of landscape drawings' edges; purposeful/ planned versus natural/found, ingenious combinations weave their pleasure.

Visually witnessing the at times mighty, at times intimate, spectacle of inadvertent land/line juxtapositions (linkages whose contextual perceptions are often highly idiosyncratic) can resonate to astonishing dimensions. Working deductively from such encounters, the lessons are the same as those learned from the passionate integrity of a draughtsman's lines.

Once, deep within the bowels of an ancient library, a curator hefted an enormous folio of Piranesi's *Carceri* towards gluttonous eyes. Dantesque in content, the character of the etching's intaglio lines, as they quickly swept the copper plate, heightened the nightmarish drama of imaginary forsaken spaces. Controlled, tumultuous strokes brought the forbidding *Prisons* to life as the needle easily tore through 'soft ground' surfaces. Etched deeply, they printed darkly; expertly building schizophrenic architecture's fearful silences. How very different are the woodcuts of Utamaro's sensuous ukiyo-e ladies. His was a comfortable line, projecting ease and elegance with a premium on grace. In his translucent realm 'the floating world' paused to reveal private moments with taut lines caressing flesh and fabric.

Sit in a darkened theatre during 'tech week' for a new production. Watch as actors rehearse their lines, as the lighting director composes his 'light cues'. Inexorable discovery, what works and what does not, builds unerringly towards that moment of 'freeze' when 'it is what

Rite of spring.

it is'. Watch as all proceed through a 'stumble through', 'dress rehearsals' and finally to the hoped for perfection of *Opening Night*. Michelangelo's red chalk drawing of the Libyan Sybil is the same study in process, albeit a linear not a lively three-dimensional one. It is drawing as thinking, preparation for that one moment when confidence confronts a challenging, briefly blank, frescoed surface. In that Renaissance artist's fingers, the language of line spun expertly within the tonal capacities of chalk, as an inner voice intuitively adjusted proportions and perspective – rehearsal for eternity.

Generations later, standing in solitary admiration in a great chapel alive with the culmination of energy and power that humble lines first created, the magnitude of accomplishment is overwhelming. Seek the distant vault where Sybil turns, and you bluntly understand that perfection can only come through questing. On paper you have seen the searching through awkwardness and failure. In fresco you watch the mind grasp content, and with sublime dexterity, hand it to Life.

In the public arena one must initiate change with care, for there are sometimes many questions with no answers; actions can have unintended consequences. Whose landscape is it? What is the anticipated longevity of the contribution? What purpose will it serve? How does one physically approach it? What time of day or season is the optimum moment for enjoyment, participation, contemplation and meditation? What are its constituent components? What maturation is necessary? Is it to be a virginal gallery-like offering for a brief time, or is it a longer-lived interactive experience between people and history?

Imagine your ascent from the dark, hard quickness of an underground passage between JFK International and New York's Central Park. Meant as a serene gift to a city's people, dwelling, working in the midst of driven, dense, super intense conflicting states of action and idea, a carefully designed 'natural' world, a conjured space appears as tonic, with one purpose – to restore equilibrium. The Central Park drawings on paper of Frederick Law Olmstead and Calvert Vaux, interpreted in earth and stone, were often buffeted by budgetary restraints. In its history the park was lost, and then found, then lost and found again – its importance to the life force of the city never entirely negated. Unlike a drawing upon copper, paper or clay, change in a landscape often reaches beyond gently imperceptible and tilts towards noticeably violent. Without dutiful, incremental maintenance, a public space can die; its spirit broken, no longer able to solace a city. Nature within a highly planned context cannot go untended before collapse is imminent. Change is always a given. One chooses to work positively with it, or disappears beneath its onslaught.

What could encourage a humbled city? What could minutely deflate chaos, pushing forward a modicum of balance and serenity? What place does a linear intrusion of glowing fabrics, undulating in orange shimmer hold? Slashing through a seasonal (physical), cultural (psychological) chill – how could Art fan life's vital embers? Not unlike the dashes distanced from each other on the airport highway, *The Gates* by Christo and Jeanne Claude accomplished this. Strolling portions of the twenty three mile-long three dimensional 'drawing'

Landscape drawing, polka dot garden.

in Central Park, on a frigid silvery February day, a stranger's eyes caught credulous smiles grasping unexpectedly delightful moments, grateful for a brief return to unapologetic childlike innocence. Public, massive in scope, with years of planning, persuasion, and marketing (1979–2005) culminating in a brief, expensive execution and existence, it created joyous memories for multitudes, as well as comedic fodder for an uncomprehending popular culture.

Responsibilities, obligations, and duties – these are not tepid words. They imply a measured conduct in action, both to the land and to the artist's evolving capacities; a pragmatic approach to connecting physical and invisible realities. William Cobbett's quiet admonition in the *The English Gardener* (1829) 'the thing cannot be done well without previous preparation', is a resolute departure point for joining the breadth and depth of two disparate disciplines. By studying the history of both we return full circle to our own 'theatre'.

First comes the measuring of spatial dimensions, tethered to time ephemeral (seasonal presentation), time maturing (years, decades); light (amount, angle, natural, artificial); and expected predation. How many white-tailed deer does it take to convert a graceful seven hundred and fifty foot long undulating Hosta Seboldiana line (speciously planted as transition from flowing blue to solid, chartreuse, grassy paths), to sustenance for a winter-weary nomadic herd? How many veteran or yearling beavers does it take to fell a decade's worth of maturing ornamental cherry, dogwood and crab apple trees or to clog a system of seven descending *Lady Pools*? How many muskrats does it take to breach a dke, setting up an unseen weakness blown in winter's rush to leave? What place do ideas born of walking and looking, of recognizing observant reality, hold next to fantasy and wilfulness?

As an artist-gardener one does not work with landscape without continuous awareness that one is never a commander of these spaces; oftentimes not even a partner to them. One is a steward, aware that blindly, egotistically enjoining one's will (knowledge gained triumphantly in other disciplines) has repercussions. As an eastern sky brightens over a muffled figure easily weeding in the early dew, or reflects off heavy machinery as another crafts terraces and pools, one is merely setting the stage for brief delight. There is always a respectful nod to powerful forces, whose permission one accepts tacitly. Tenure has a contract; a lifetime of stewardship – editing and guiding are its calm prerogatives – but always the unspoken directive hovers: share with others.

Mortal drawings upon the land are at best tentative collaborations – time ultimately outlasts all matter. Whether intrusions, or palliative amendments, drawing in the landscape is a humbling experience. If those gestures wind and rewind in covert memory, are they not equally valid? Can they not bear wisdom's weight, though inaccessible to many? If drawing is the organization of space, a skilled individual's viable expression of priorities, what pride comes from nature's contributions? Few have the will or the means that supported Louis XIV's commission to Andre Le Notre creating Versailles, or the Bishops of Viterbo who created The Villa Lante above Bagnaia. Few there are who can mould a swamp or tame a hillside.

First one must enjoin fantasy, grateful for decades of unobtrusive botanical support, background for epiphany, then commencing with reality, connect the dots with what is, what can be, what should be, what will be. Standing in the wings, not stage centre, quietly we access the lie of the land, light, scent, sound, movement that has embraced us for decades, a place where weather knows our limitations and preferences. We watch the cues, as exhausted night signals nervous day; as winter melts to spring's impatience; as whispering chevrons wing northward and wild turkeys retreat to woodland invisibility, no longer reverse apostrophes, tall, hesitant, hungry, emerging fluidly from the frozen verge of Lower Pond, walking unerringly across hardened snow (their claw marks a wavering line up the barn's snowy incline) – to steal the chickens' feed

It is here as steward/editor to this land (for however brief a time) where one may extend the skills and talents, observations and intuitions long earned in self-contained studios, to investigate one's own large, lively canvas, away from interruptive gallantry and gratitude. Poised to work and think without formulae, without specious rectitude, thoughts of the coming journey's twists and turns exhilarate.

Some lines are purposeful, immigrants from other sensibilities: limestone rocks placed to raise settling forest paths, their whiteness an unexpected sidebar to winter's reigning hue, serf to Fletcher Steele's *Naumkeag* with its memorable staircase drawn in painted steel and Paper Birch; daffodils emerging with staccato crispness, stroked in plans struck long ago, as ephemeral gestures to survival; timber, felled in time's secret schedules, its insistent verticality mellowing, softening, as moss and lichen assert a horizontal plane. The botanical world provides the actors. Research, time and treasure are the technical crew that makes it happen. If it is your durable space (not a transient contribution), if work on one section of reflection, immediately posits another, can satisfaction be other than a limpid smile?

One cannot always initiate change to worldly policies, but one can affect those decisions within one's own sphere of caring and connections. If chaos lies without, then within, one can try to create peace; opening doors to opportunity and chance. We cannot believe it only opens once, then closes to oblivion. Taking darkly bruised, neglected spaces and turning them toward the sun (although over the span of decades); expressing a personal perspective through hard earned hours placed within the context of one's own ideas, leads by example. Ripples spread – who knows how far?

9

Hew Locke on Drawing and Sculpture

In conversation with David Cottington

Hew Locke was born in Edinburgh in 1959 and spent his late childhood and adolescence in Guyana. He returned to Britain in the early 1980s, studying Fine Art at Falmouth School of Art, where he gained his BA in 1988 followed by MA (1994) at the Royal College of Art.

Hew Locke's art is in collections in Britain, the USA and elsewhere, including the Collections of Eileen Harris Norton and Peter Norton, Santa Monica; the West Collection, Philadelphia; The New Art Gallery, Walsall; The Victoria & Albert Museum Drawing Collection, London; The British Museum, London; and The Henry Moore Institute, United Kingdom. He is represented by Hales Gallery, London.

David Cottington is Professor of Modern Art History at Kingston University London, and the author of several books on Twentieth century art, including *Modern Art: A Very Short Introduction* (Oxford University Press, 2005).

Hew Locke, in conversation with David Cottington, echoes a scenario from the mid 1980s when David Cottington was one of Hew Locke's tutors at Falmouth School of Art.

This conversation identifies a clear purpose for drawing in the work of Hew Locke in that he succinctly states that drawing is the backbone of what he does and [drawing]...is where it all comes from. The conversation discusses the relationship of drawing, including found objects through to the making of sculpture, which Hew Locke determines as drawing in three dimensions. David Cottington provides the reader

with statements that act as points of summary whilst expertly facilitating further dialogue, providing us with some new insights into the purpose of drawing within Hew Locke's practice as a leading international contemporary artist.

Growing up in Guyana gave Locke an ironic distance from Britain and from its dominant attitudes to its former colonies. He has used this distance to destabilize stereotypical ideas of Britishness and colonial exoticness; often in ways that combine humour with hints of menace, fashioning magnificent fetish-like objects from cheap, unspectacular materials: cake decorations, paper garlands, crocheted remnants, and plastic toys. Among the best-known of these has been a series of 'portraits' of members of the Royal Family as voodoo icons, rooted – as this interview reveals – in his adolescent fascination with an inescapable, ever-present but also alien cultural authority.

The series includes five cardboard cut-outs representing the Queen, Princess Diana, and Prince Charles. Inspired by images on travel postcards, their likenesses are formed by a lattice of small serrations into large sheets of cardboard, each highlighted by white paint and black marker pen. The use both of this material and of this way of drawing on it has played a central role in his art practice, most spectacularly perhaps in his installation Cardboard Palace, first shown at the Chisenhale Gallery in London in 2002. In this monumental cardboard construction the viewer is surrounded by a hybrid of Baroque, Rococo, Islamic and Rajput architecture in which are secreted yet more items of royal memorabilia.

Recognition of his original vision and the immediate appeal of his work came quickly to Locke, with a solo exhibition *Ark* that toured from the De La Warr Pavilion, Bexhill on Sea to the Oldham Art Gallery and Museum and the Gardner Art Centre in 1995 and 1996. This was followed by *Hemmed In* at the Millais Gallery in Southampton, and by *Hemmed In Two* at the Victoria & Albert Museum in 2000, *The Cardboard Gallery* at Chisenhale Gallery in 2002, and *Souvenir* at the Horniman Museum in the same year. In 2004, *House of Cards* was shown at Luckman Gallery, California State University, Los Angeles, and The Atlanta Contemporary Art Center, Georgia, USA, and in 2005 he was given a solo exhibition at The New Art Gallery, Walsall. His work was included in the British Art Show 6 that toured the country in 2006.

David: You are a sculptor; you've been profiled as much as anybody in the recent British Art Show that toured the country and you're making a reputation as an artist working with 'found' materials of various kinds, artefacts, consumer objects, and putting them together around notions of identity. I am wondering what that has to do with drawing, and how useful drawing is in that process.

Hew: Drawing is, I suppose, the backbone of what I do; that is where it all comes from. Obviously a lot of thinking as well! Say for example: the objects I've been making recently are quite baroque in appearance and this comes from lots of drawing in cathedrals, mosques, museums... you draw to sort of get a feel of something you actually like. I don't draw things I'm not interested in! You see

Mosque, West Bank, Demerara, Guyana, 1992, British Museum Collection. Photograph FXP Photography.

something you like, or you see something – as in the case of certain objects – I see something that really scares me! Many years ago, I remember looking at an old African carving with snakes wrapped around it and magic material smeared over it and it was a truly intimidating object, I thought. Obviously it was intended as a ritual thing. I had to draw it to come to terms with it. I drew this piece in the Metropolitan Museum in New York and now it doesn't bother me any more. I sort of own the piece to a certain extent.

David: That's very interesting – it sounds like you need some kind of real engagement with what you're drawing before you can make use of drawing to make an artwork of it. Is that part of it? Is it that the engagement stimulates the drawing?

Hew: Yes, the act of sitting and looking at it for a long period of time and figuring out how it's actually constructed – that actually helps in going to make something that's completely different and may not even remotely resemble what I'm actually working from. It leads away from the object as much towards it. For example, I spent some of last summer in the Victoria & Albert Museum and in the Wallace Collection drawing old firearms and Baroque clocks and out of this has come the start of a collection of military type shields and heraldic images.

David: Is that to say, then, that drawing is always at the start of your thought process for a given work?

Hew: No, drawing isn't always at the start of it; at times particularly if the inspiration comes from travelling somewhere and you're only there for a short period of time and you don't have time to draw, then it comes from memory. I don't necessarily draw – you could stretch a point and say it comes from the imagination when I walk around the Victoria & Albert Museum, which is where I get a lot of my inspiration from. I actually construct things; I work problems out in the Museum – looking at things there and looking at the space next to it and thinking right, if I build that bit and that bit. I build and destroy, build and destroy, all in my mind.

David: Can we explore this idea of drawing to learn something – has that kind of drawing always been interesting to you?

Hew: Yes, for sure – this is something I probably developed at Art School, the recording drawing where I sit down and at the end of the day I'll have an idea of how something works; it could be a skeleton, I don't know, it could be any thing like that. Years ago I saw this exhibition of Bonnard's drawings; these are like small stubby, scrubby little things, and I thought that there was something hesitant, fragile and insecure about them. But these things really stuck with me; they were really quite a striking show. My whole drawing style in pencil was based on that. I had an idea of what he was trying to do; there was something intuitive I picked up from that and after that I worked in pencil in a similar way and then developed my own style of working. It's partly instinctive, but there are certain qualities that you can get from sitting down in front of a building and doing a graphite drawing. And that's from life and drawing from life is good in a

way, but there are limitations and the imagination is held in check. And there is the other type of drawing that I do which is me by myself in the studio and that's the imaginary type of drawing, and that's usually in pastel or charcoal.

David: So that kind of drawing is a way of articulating your imaginative response to an idea. It does sound as though drawing is for you a lot more than it might be for other artists. It seems to be central to the visual images that you work out.

Hew: I would say so. Years ago when I was on my Art Foundation course there was a tutor who couldn't understand how Rodin could produce the muscular sculptures he made from drawings that seemed to have absolutely no connection to them. Now I may not be the hugest Rodin fan but I have always liked that gap between these loose watercolours and what he ended up creating. For some reason I thought of that for years afterwards, and so when I am actually making sculpture – it's modelling and the modelling for me is along lines. So in a sense when I am actually doing something it may not obvious to other people but to me it's actually drawing, drawing in three dimensions.

David: What is the significance for you in thinking of it as drawing?

Hew: It is to do with line. Drawing as I see it is a very wide thing. The sculptures that I had in the British Art Show included some Queen's heads. There is stuff dripping off her face and to me those are just lines. Those lines are absolutely essential to how the thing works; the lines may be in beads, it may in lace, but it is essential to how the thing works. On one image, Black Queen, she's covered with orange lizards, but those lizards move in a rhythm. And that rhythm is a drawn rhythm as far as I am concerned.

David: What is so engrossing to you about that linear quality of things?

Hew: It's how things flow, it's how you get movement. Years ago I was in a studio working along side some kinetic artists and all their stuff literally moved. I spent a long time trying to figure out how I can make stuff move when I don't have the skill or possibly the interest in putting motors in the work. The way a car with 'go faster' stripes on the side – that cartoon thing – looks as if it is moving faster. It's about movement and rhythm. I've seen it as well in Indian images of Krishna dancing. He's in the centre and these women are in a circle around him and you look at him and they're moving. That's to do with that incredible discipline or skill that Indian miniature painters have of the drawn line (colour as well, colour makes the movement too) but the basis, the ground of it, is an absolutely solid drawing practice.

David: There was a time when you seemed to privilege drawing above other ways of making art quite considerably. How did you move from that work into the kind of sculptural work for which you are now known?

Black Queen, 2004, Cherry Brisk Collection.
Photograph FXP Photography.

Spellbinder, 1998, The Victoria and Albert Museum
Drawing Collection London. *Photograph Hew Locke*

Hew: Sometimes as an artist you decide to do something and you try not to question it. So I was looking at photographs by Cecil Beaton of Princess Margaret on her sixteenth birthday and I suddenly thought I wanted to do a drawing of this, and so I did a drawing and it was of her in a sense covered with tattoos and stuff all over her face.

David: Was the drawing a means of zeroing in on the things that really interested you?

Hew: The drawing was a means – a similar way of using drawing to the way I used it in response to that African carving back in the early nineties – the drawing was a way of coming to terms with something which I didn't understand and made me feel pretty uncomfortable, made me feel quite weird, to be honest with you. The drawing was a way of dealing with something, but I didn't know what I was dealing with. It took me six months afterwards to realize what this was about I remembered some friend when I was very young giving me loads of books on the Royal family; God knows why. There was something deeply depressing about these books. I don't know whether it was the smell – books have a very particular smell – who knows why children remember things? I certainly remember this very clearly. That was why I was doing this, and then it developed into an obsession at the time with the Royal family; a very personal thing.

David: It seems, to come back to the kind of drawing aspect, of that ... that it is a way of making it yours and of being able to select and allow your own imagination to run riot, if need be, but certainly to do what it will. Rather than, say, taking photographs, rather than any other medium, you find drawing a very natural way of seeing things.

Hew: It is a natural way of responding to something; it's a natural way of thinking and at times these drawings, the early ones I did of the Royal family, were quite important to deal with something. But at times, to be honest, the background of the drawings was maybe even more important than the actual drawing itself.

David: So there's always the accident of what's coming out that draws your attention; to look at the broader picture. How do we go from there to things like Cardboard Palace for instance?

Hew: From these drawings, years before, I'd done some cardboard sculptures, and for my degree show after going to Guyana, the pencil drawings gave rise directly to a large papier-mâché sculpture which was cardboard covered in papier-mâché. But papier-mâché sculpture took too long to make, and I got more interested in the nature of cardboard, and in the idea that it is essential for contemporary living – but at the same time it is completely disposable.

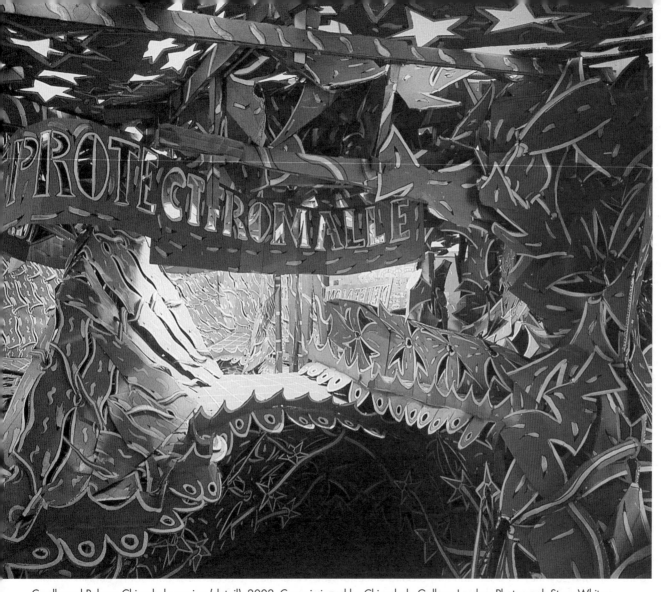

Cardboard Palace, Chisenhale version (detail), 2002, Commissioned by Chisenhale Gallery, London. Photograph Steve White.

David: So the material that you used came from cardboard that had been used in boxes and other things. It wasn't buying rolls of pristine cardboard?

Hew: Exactly. It started with picking cardboard boxes up on the street, usually in Brick Lane, boxes that had come from Thailand, which have this beautiful colour unlike any other. But then it became more serious, and I started getting huge sheets and cutting it as if it was wood. So cardboard became like a cheap form of wood. Cutting it with a Stanley knife and following shapes and rhythms which are natural to turn when you are cutting something freehand. I started cutting shapes which would move – so the shapes initially were, say, an arrow, a directional arrow. But that didn't move enough so I lost part of the arrow and just ended up with the head of the arrow, then you curve the arrow with a cut and that starts to move a bit more .

David: But it's also about drawing – these shapes, the edges of them that make the movement, that's something that you are carrying over from your excitement about drawing in a more conventionally understood way into the three dimensional and then you are playing that off against these painted lines and these felt tip lines. So that even when you are using a material like paint which can move away from drawing you are using it in this very linear way.

Hew: It's a very linear thing; even the cuts weren't enough. And so, then, you had to do the cartoon type way of doing something so there were other lines drawn next to a multiplicity of lines drawn next to this cut out hole, to create movement. But then you have to always take it to another level and the other level is then to bend that, twist that, so the drawing itself is bent and twisted into an organic form, and so the drawing then literally becomes sculpture.

David: Is there any sense in which you're playing off the kind of pedigree of drawing against the kind of 'low' culture or popular disposable aspect of cardboard. Is there a little bit of irony in there?

Hew: I'm not sure whether it's irony – I mean it is about taking something which is quite cheap and rubbishy and turning it into something quite special.

David: Which is quite like Picasso – how he would take little bits of cardboard and other throwaway material – the dross of everyday junk – and turn it in to the gold of art, so to speak, by the alchemy of his imagination.

Hew: People often used to say to me – they don't say it any more – 'but it's cardboard – how is it going to survive?' And I always quote the Picasso cardboard stuff and say they've been hanging around since forever. What these pieces are is cardboard cubism – that's basically what they are. I mean cubism sort of has had a huge impact on what I do.

David: What in particular is it about cubism, for you?

Hew: It's the space – it's going into other dimensions – its space and angles and believing that there are things behind what are the surfaces. It is a formal thing which takes you into another world – it's the only way I feel that you can actually do an image and get to somewhere else.

David: That seems to tie in to your interest in the way drawing suggests movement. The fact that you can create an idea of movement; similarly you can suggest a convincing idea of something going in the background in ways that aren't obvious.

Hew: Exactly, exactly; though I do have a problem with cubism – I don't actually much like hard analytical cubism – I like it when it got softened out. It was one of the dominant themes of art I grew up with around me in the seventies in Guyana. All these people doing cubism, its influence was just phenomenal. And cubist painting has been a colossal influence on what I'm about. In particular some of Juan Gris' work. I like the fact that Gris had gone full swing through cubism. He took it and did things with it and used it as a tool. For me, I use it as a tool.

David: Can I ask you what sort of ideas you are working on at the moment and how drawing feeds into that?

Hew: There is some stuff I'm just about working on, which is working with laser cutting. One idea is a heraldic image which I have shifted, adjusted, changed in a simple line drawing and that has been projected and turned into a staple gun drawing on the wall. It is done in black cord, stapled along the lines projected from an OHP – so it's a line drawing on the wall. This is *Evil to him who thinks evil....* Which is a sort of a rough translation of the motto *Honi soit qui mal y pense*. That's become something I'm just about looking into right now. How it's possible to turn that into something completely different. I have had that laser-etched into a small A4 sized acrylic mirror. So I am thinking of ways of manufacturing things.

David: It seems to me that the way you're using drawing has extended from those beginnings in either recording or improvising imaginatively, into a way of carrying the meanings that come from outside of the formal arrangements.

Hew: Yes, it can be as wide or as narrow as you want to make it – that's the way I see it. I don't sweat too much about what's right and what's wrong theoretically. This works if it feels good for me.

All Images copyright Hew Locke and DACS. Courtesy Hales Gallery London.

10

'DRAWING IS A WAY OF REASONING ON PAPER'

Andrew Selby

Andrew Selby is an award-winning illustrator and academic. His work has appeared in newspapers, on billboards and on the covers of major corporate reports for household names for nearly two decades. His work has recently been selected by 3 × 3: The Journal of Contemporary Illustration, Society of Illustrators' and the Association of Illustrators' Images juried exhibitions and annuals.

His research activity as an academic at Loughborough University in the School of Art and Design centres on the investigation of the importance of wit and humour in visual communication.

His first book, *Animation in Process*[1] is due to be published in spring 2009 and showcases prominent animators, directors, producers and studios at work in this expanding field. He is currently writing a second book, *Animation,*[2] with fellow academic Andrew Chong (forthcoming, 2010).

Andrew is also a co-editor of *TRACEY,* the open access online journal dedicated to exploring contemporary drawing practice and theory, and co-author of the book *Drawing Now: Between the Lines of Contemporary Art* (2007).

His work is held in public and private collections in the United States, Australia, Japan, New Zealand and Saudi Arabia. He is represented worldwide by artists' agents Illustration Ltd.

The title is a quotation that he has remembered from a text by Harold Rosenburg on the works of Saul Steinberg (Rosenberg 1978).

Andrew Selby in his role as an illustrator discusses drawing as problem solving. He makes drawings at a variety of points during the process of creating an illustration. It is a required element; it is interactive and never forgets that it must function as the framework to communicate a subject to an audience. He illustrates that drawing is adaptive, exploratory and editorial. Drawing acts as an information exchange.

The essay explores his decision-making process by highlighting a selected number of projects where the purpose of drawing has been continually questioned, to arrive at an outcome that is unexpected but recognizable. The external client is often unaware of this process – indeed they simply require an original approach to solving a design problem. What happens between being briefed and completing the work is a journey of discovery that may or may not be replicated.

He sees drawing as a process of self evaluation that seems both natural and important and for Andrew Selby that is why drawing has a purpose.

I see the role of drawing in my work as being one of problem solving. For me there has always been a very thin line between function and form. As an illustrator, an image has to function, sometimes through it's form, sometimes because of its form and very occasionally, despite it. I have always thought of drawing very simply as a tool that can describe my thought process into something more physical for others to understand. Of course, drawing manifests itself at different stages of my thinking and working process, but its purpose is to act as a vehicle predominantly for describing ideas, thoughts and notions.

I make drawings at a variety of points in my work – for example, as scribbles on post-it notes on the telephone to a client; in a series of sketchbooks left around my studio; on the sides of other drawing projects; as collages on my work table; as digital photographs; and on screen using a drawing tablet or a scanner. This has become instinctive. Drawing becomes interactive, in the truest sense of the word, because the modes by which one thinks, questions and comments through drawing transcend media and platform concerns and focuses directly, in my case, on the communication function of the illustrative project in hand. The purpose of drawing here is to continually question content, exploring the codes and conditions by which the content could be absorbed by a third party, creating 'mnemonic symbols or a pictorial symbology' (Heller, 2002). Or if you prefer, (I don't) it is what the nineteenth century essayist Rodolphe Töpffer described as 'a language of signs' (Raeburn, 2004). Whilst the process of my drawings has been described by others as private, expressive and reflective, I try to never forget that it must function as the framework to communicate a subject to an audience.

Intriguingly, in my commercial work at least, I seldom have the opportunity to see how my work engages with an audience in the moment. The closest I ever come to that experience is if my work is shown in a gallery setting, or if I have been commissioned, say, by the *London Evening Standard* to produce the front cover for their supplement and most of the commuters on the tube on a Friday evening are reading

it. Producing work for publishing involves a curious parting of the ways from the original creation. Handled by a talented designer, this can raise the contextual quality of the work markedly. I believe that this idea of a loss of control probably explains why the purpose of my drawing activity and research has become so important and also so stimulating for me. My personal work closer reflects my studio working ethos on a day to day basis because I have greater control over all of the defining factors and, like other artists, I take great care of these opportunities and actively seek to utilize them in my commercial work. I am fortunate in having a good relationship with my artists' agents, Illustration Ltd., (www.illustrationweb.com) who actively encourage evolution in practice as a clear and lasting mandate in their promotion philosophy, and this process of change is both welcome and necessary.

Approach and Philosophy

Essentially I produce illustrations – but where does the term drawing stop and the word illustration start? Simple answer, it doesn't. I believe that my role as an illustrator is to examine, investigate, and seek to interpret, to reposition and recontextualize material for an audience to understand a message, instruction, and body of narrative or reference. The purpose of drawing is inextricably linked for me in all of those areas, largely because I use it as an adaptive medium; it allows exploration and, at the same time, editing, My primary influences have always displayed strong drawing characteristics as a foundation to what they do: Saul Steinberg, Andre François, Tomi Ungerer, Kvêta Pacovská, Benoît Jacques, Ed Fella, Jeff Fisher, Andrzej Klimowski, Ian Wright, Marion Deuchars, Patrick Heron and others. From that point of view, I am less concerned about the importance that some place on things like job titles. I can see it is convenient for the information-based, file culture world we live in, but I don't particularly identify with that line of thinking. My multi-disciplinary approach to drawing resonates with this definition by Paul Bowman in an essay by Teal Triggs, exploring the role of an illustrator: 'There are so many strands to illustration at the moment – visual translator, new imagist, visual journalist' (Heller, 2000). I use drawing to illustrate research, teach and tell the milkman how many pints he should leave on the doorstep. Importantly for me, drawing acts as the conduit for information exchange coupled to aesthetic questioning, as Roanne Bell and Mark Sinclair imply, 'By it's very nature, the single panel denies any pictorial sense of "before" or "after" but instead captures a moment in time, using it to tell a larger story' (Bell and Sinclair, 2005). It also operates as a universal device by which people can understand my ideas if written or spoken dialect is not common.

My drawing work tries to encapsulate analytical, social and emotive contexts because I realized early on that my work did not locate in a cultural vacuum. This message is obviously enforced by some of the subject matter I am commissioned to deal with, but has also had a positive reaction on my approach to the way I utilize drawing in personal projects. Largely because of my background, I often include cultural references in my work as a natural reaction to personal observations I have made through travel, study and reflection. I relate strongly to the words spoken by Saul Steinberg in one of his many conversations with the critic Harold Rosenberg, where he describes the intentions of his drawings as 'appealing to the complicity of my reader who will transform this line into meaning by using our common background of culture, history and poetry. Contemporaneity in this sense is a complicity' (Rosenberg, 1978). What happens between

Sketchbook.

Sketchbook.

Sketchbook.

Sketchbook.

being briefed and completing work in the commercial sense or instigating a personal assignment is a journey of personal discovery that may or may not be replicated, and the external client is often unaware of this process – indeed they simply require an original approach to solving a design problem that they, and therefore their audience, will be able to identify with or, indeed, aspire to.

I always carry a sketchbook with me. I work in a variety of sizes all at once and this approach has served me very well when, at difficult moments and with impending deadlines, a trawl through my library of sketchbooks will often throw up possible solutions to visual problems with some work. I like to work in different places, different conditions and with a variety of media.

when I'm on my travels – I'm a big fan of the Moleskin range of sketchbooks, particularly the ones with the pouch at the back, where I can store interesting beer labels (like Magic Hat), or lists, or scraps of paper that I might use to collage with later. I also like to create images with the camera on my mobile phone. It has a relatively poor resolution, extremely frustrating for those who use it to record events, but very useful for me who has a memory full of ambiguous images that could act as a starting point for a drawing or series. I also carry an ideas book, which is full of thumbnail drawings – I confine lists to academic work but in the studio environment I always draw, thinking of lists as sequences or as visual prompts to explore further later when I have the opportunity.

Projects

The brief for NEC was essentially to communicate the idea that in-car anti-collision technology could enable people to drive efficiently and safely in urban environments without fear of injury or accident. The piece of technology in question was a microchip, inserted into the information technology of the car's engine, and whilst being undoubtedly a smart piece of kit, had very little resonance with the average person on the street. My initial drawings from this project can be traced back to a holiday visit to Seattle, famous for being one of the main inspirations behind Gerry Anderson's pioneering puppet-based *Thunderbirds* television series of the 1960's. Our hotel room was at eye level to the city's Skytrain and I made a series of drawings inspired by the whoosh of the rails. Here, the grid-like town planning of a major North American city had yet another dimension; height, and a three dimensional grid is apparent. This grid-like structure became an important compositional device and further inspired later research into skylines, aerials and masts (the RKO identity is another clear inspiration for this piece) and formed the basis of how I wanted to deal with the urban environment of the NEC drawing.

The client was eager that the focus of this campaign was making women drivers feel empowered to drive in situations that market research in Southern Asia had suggested they might not. My initial drawings served to reassure the client that I was working in a clear compositional structure with a balance of elements, supported by a limited colour palette that used green as its primary base, supporting the theory of safety and progression. Working for clients internationally often involves careful liaison and a sensitive approach to local customs. This cannot always be done through writing, particularly with the emotionless patter of email correspondence, or through speech where

NEC.

Skytrain.

differences in language become a barring factor; yet drawing can be universally understood. The success of this project lay in meshing together a complex message in a simple way, and the act of drawing was used to visually unlock the client's problem and gradually refine the subject through a sequence of drawings towards a simplified core solution.

One of my favourite drawings is *Flag*.

I often have ideas for drawings in odd places. I had seen an advert to design a flag in support of Australian independence, and, despite not having a strong view either way, I was drawn to the project because I have always been inspired by flag designs. In this case, I had been up the CN Tower in Toronto and was coming down in the lift, when, peering over the shoulder of a fellow tourist, I spotted the solution to the problem on a page of her magazine. I made the drawing on a napkin in the downstairs restaurant, taking inspiration from the dotted line clipping from the corner of the advert and applying it to the Union Jack positioned in an identical position on the Southern Cross. I sent it to the organizing committee, who sent me a letter informing me that they thought it would be 'too inflammatory to exhibit under current conditions.' The drawing is so pure and innocent whilst knowing exactly what it was implying.

My aesthetic is governed by enquiry. I see students who are desperate to find a style. I see style as something that goes in and out of fashion. It's fickle. Today we have publications like *Vitamin D – New Perspectives in Drawing* (Dexter, 2006) promoting drawing as something that has come back into fashion. Of course, drawing has never been away but, like all other modes

Flag.

Environment.

Architecture.

Environment.

of the visual arts, it has its highs and lows. I take the issue of being surrounded by visual stimulus very seriously. My studio is full of objects of curiosity, often drawn or found, that can act as a catalyst for my work. I try to change my pin boards regularly so as to not let my environment become stale. Even the pins are carefully chosen to compliment the colour of the images being put up. So whether it is Mexican handicrafts, Japanese vinyl toys, Zolo™[3] wooden construction pieces or Eastern European posters, everything has a place and potentially a bearing on the drawings I produce. My work manifests itself through natural concerns: colour, design, scale and these are all borne out of enquiry and substantiated through knowledge.

I was commissioned to make a series of drawings for Redpath Design who, in turn, had been briefed by the International Council of Shopping Centres (ICSC) to provide pavilion banners for their international exhibition in Copenhagen in 2004.[4] This project again required a level of delicacy and understanding following much heated debate, particularly in Europe, about retail chains building on environmentally-sensitive sites, and the resulting negative publicity that was likely to ensue. One of the series of drawings was to promote the seriousness with which the ICSC took its environmental responsibilities and I began to make studies of landscapes, from a mixture of visits and adaptations from previous sketchbook drawings, to illustrate the idea of integration and harmony. The key to this piece of work, like so many others I could have chosen, came from a chance happening, drawing a toy Rubik Cube. A blue square in the middle of a green side suggested a feeling of isolation, and I made a series of drawings about how the blue square returned finally to its blue side using sticky labels. In the middle of making this series I realised that I could treat the design like a tapestry, fully integrating a revolutionary new shape by revolutionizing the environment surrounding it. I made drawings with traditional set squares, protractors and ruling pens, then cut them up and wove them together to create my designs. The design company and the client loved the final designs and they have since gone on to be recognized by awarding bodies.

This woven approach can also be seen in the pieces *Fall in Love with New England.*[5]

and *In England's Green and Pleasant Land*[6] where I used increasing mixtures of coloured paper and neoprene to cut and sculpt shapes to draw from, or photograph or scan to use in differing measures in my final pieces. This led onto constructions using Fimo[7] and making small self-contained sculptures that I could draw from. In all of these drawings, I was experimenting with the scale of objects and how they related to one another in both physical and emotional states and, in turn, how I, the creator, related to them. This process of self evaluation seems natural and important, the process of evolution continuing through being involved in producing work. That is why drawing has a purpose.

Fall in Love with
New England.

In England's Green and Pleasant Land.

References

Bell, R. and M. Sinclair (2005) *Pictures and Words*, London: Laurence King Publishing Ltd.

Dexter, E. (2006) *Vitamin D – New Perspectives in Drawing*, London: Phaidon Press.

Heller, S. (2002) *Design Humour: The Art of Graphic Wit*, New York: Allworth Press.

Heller, S. (2000) *The Education of an Illustrator*, New York: Allworth Press.

Raeburn, D. (2004) *Chris Ware*, New Haven, CT: Yale University Press.

Rosenberg, H. (1978) *Saul Steinberg*, New York: Alfred A. Knopf.

Notes

1. Animation in Process, 2009, Laurence King, Andy Selby.
2. Animation, Forthcoming, Laurence King, Andrew Chong and Andy Selby.
3. Zolo™ is an original wooden toy company formed by Sandra Higashi and Byron Glaser (Higashi Glaser Design), New York, now specialising in Curious Bonz® designer toys, publishing and giftware. Further information available at www.zolo.com.
4. Environment, Andrew Selby, commissioned by Andrew Hunter, designed by Sarah Cassells, Redpath Design Ltd. for The International Council of Shopping Centres, jury selected exhibition at Mall Galleries, London in July 2005 and published in Association of Illustrators' Images 29, Design and New Media, AoI, London, UK. This piece was also jury selected for 3 x 3 Inaugural Professional Show and published in the 3 x 3: The Journal of Contemporary Illustration Professional Annual 2005 (USA).
5. Fall in Love with New England, Andrew Selby, commissioned by Sarah Munt, 3 x 3: The Journal of Contemporary Illustration and subsequently jury selected for the same journal's Professional Show 2006 and published in 3 x 3: The Journal of Contemporary Illustration Professional Annual 2006 (USA); also jury selected for the Society of Illustrators' of New York, Illustrators 48 Show and Annual, April 2006, Illustrators Gallery, New York, USA.
6. In England's Green and Pleasant Land, Andrew Selby, commissioned by Sarah Munt, 3x3: The Journal of Contemporary Illustration, jury selected exhibition at Old Truman Brewery Gallery, London, August 2006 and published in Association of Illustrators' Images 30, Design and New Media, AoI, London, UK; also jury selected for the Society of Illustrators' of New York, Illustrators 48 Show and Annual, April 2006, Illustrators Gallery, New York, USA.
7. Fimo modelling material is a similar product to Sculpey:
 www.andrew-selby.com
 www.illustrationweb.com/andrewselby
 www.lboro.ac.uk/departments/ac/mainpages/Research/staffpages/selby/selby.htm

INDEX

Drawing – The Process

Edited by Leo Duff and Jo Davies

ISBN 9781841500768 pb £14.95 / $30

This book documents and expands upon the themes from a major international drawing conference held in January 2003. Much debate has been undertaken about the process of drawing. This collection of refereed papers represents a breadth of activity and research around the issues of drawing within the broad context of art and design. The book offers an examination of the drawing processes of high profile practitioners, and encompasses the best contemporary investigation of a subject pivotal to art and design. *Drawing – The Process* is a fundamental text for students at both undergraduate and postgraduate levels.

For other related titles, visit www.intellectbooks.com

Intellect. Publishers of original thinking | The Mill, Parnall Rd, Bristol BS16 3JG, UK